CELEBRATING **WILDLIFE**
PHOTOGRAPHER OF THE YEAR

WILDPLANET

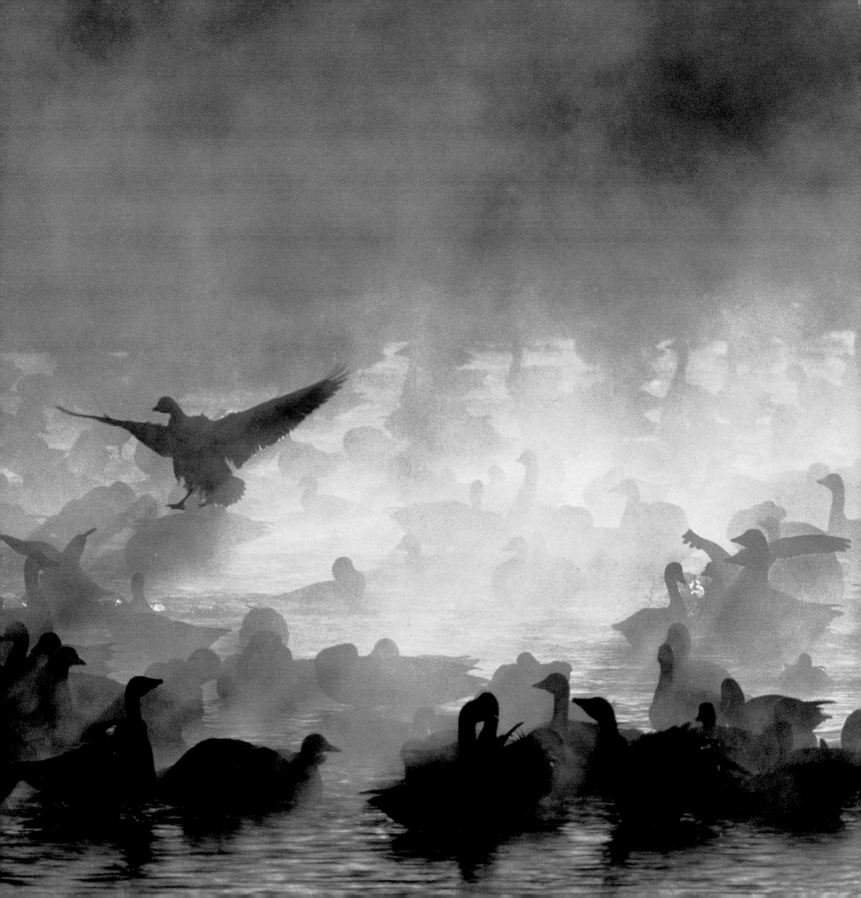

CELEBRATING **WILDLIFE**
PHOTOGRAPHER OF THE YEAR

WILDPLANET

Published by the Natural History Museum, London

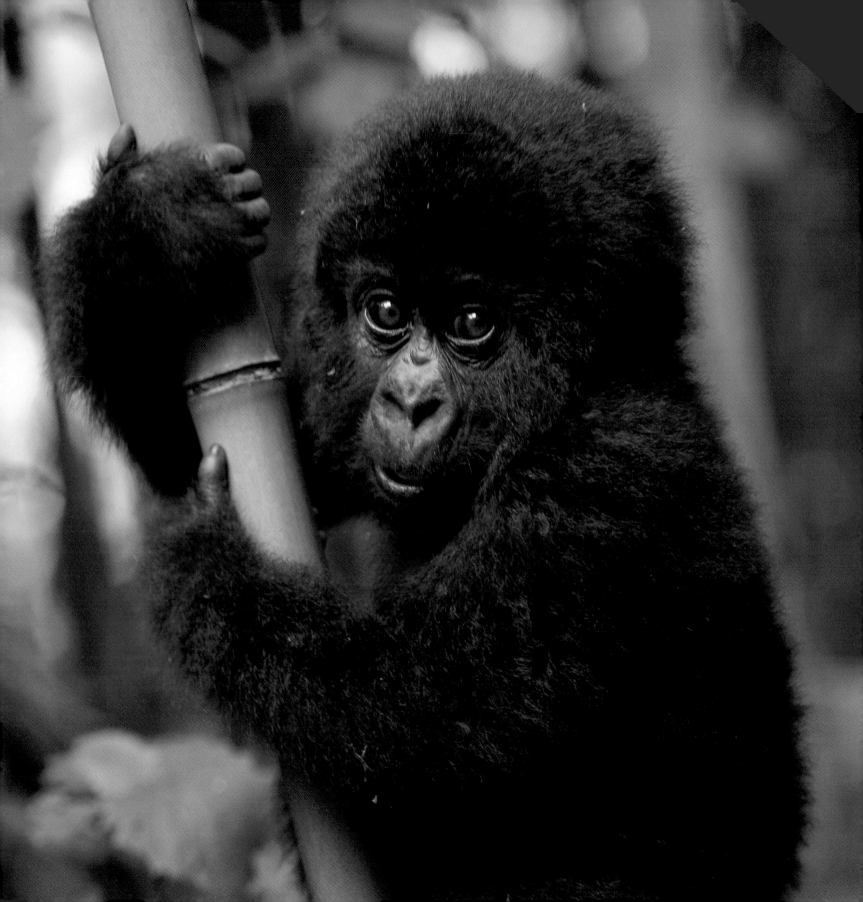

Foreword

Before you enjoy the photographs in this book, close your eyes and count slowly to five. That's how long the sum of all these moments probably lasted in real time. In fact, more than half of these exposures could have easily been captured by the cameras in less than just one second – a one second view of life on Earth. And yet, when you look, they display an astonishing diversity of that life from all parts of the world. They are portraits of the good, the bad and the peculiar; they record amazing behaviours and reveal remarkable habitats and inaccessible environments. Together they form a truly remarkable photographic celebration of life and, I'm sure, they took a lot more than five seconds to make!

Indeed, try to imagine the incalculable hours of toil, thought, anguish and even danger spent by the eighty image makers. The heat, the cold, the wind, rain, snow, the months away from loved ones, the extraordinary human cost required to give us these views into worlds we will never see, pictures of species we never knew existed, things we could never have dreamed of. And consider also that these are not snatched illustrations. These images include moments made beautiful, crafted pictures which are altogether unique reflections of each photographer's response to one tiny fraction of the Earth's time and space, and the life that filled it and their lenses. These are the unforgettable offerings of truly gifted artisans.

But where are they now, all the creatures featured on these pages? How many survive, how many struggle and what became of those that have perished? Of course some did not live long – insects and plants often have ephemeral lives – but what has become of that moonlit leopard, that submerged anaconda or that freckled whale shark hung in the big blue? And the young gorilla with the bemused eyes, what world has it inherited? I wonder, is it sleeping safe in a glade somewhere out under the stars or was it killed by poachers long ago? Give this some thought too and, if you look at the images with your own offspring, turn to watch their gaze, see these miracles of life reflected in their awe and ask what sort of world are they set to inherit themselves? Because this beautiful ark of images should also be seen as a clear clarion call from our Earth to us all. The plight of the wild planet is in our hands, hands that must urgently protect and heal its unfortunate catalogue of problems. So please try to use your experience of these beautiful photographs not only to revel in the riches of our natural world but to help secure a positive future for all the life that stalks, slithers, slimes or swims in it.

Chris Packham

Wild Planet

Welcome to Wild Planet, a celebration of some of the very best photographs from the Wildlife Photographer of the Year Competition. Immerse yourself in these spectacular and inspiring images which have been specially selected to demonstrate the beauty and diversity of the world around us. Please visit www.wildplanetexhibition.co.uk to find out more.

Wildlife Photographer of the Year

Wildlife Photographer of the Year is the biggest and most prestigious wildlife photography competition in the world and it aims to inspire and develop a new generation of photographic artists to produce visionary and expressive interpretations of nature. Each year, thousands of photographers - professionals, amateurs, young and old - from countries right across the world enter, hoping to win the titles. Jointly owned by the Natural History Museum, London and *BBC Wildlife Magazine*, the competition has been running since 1964. Please visit www.nhm.ac.uk to find out more.

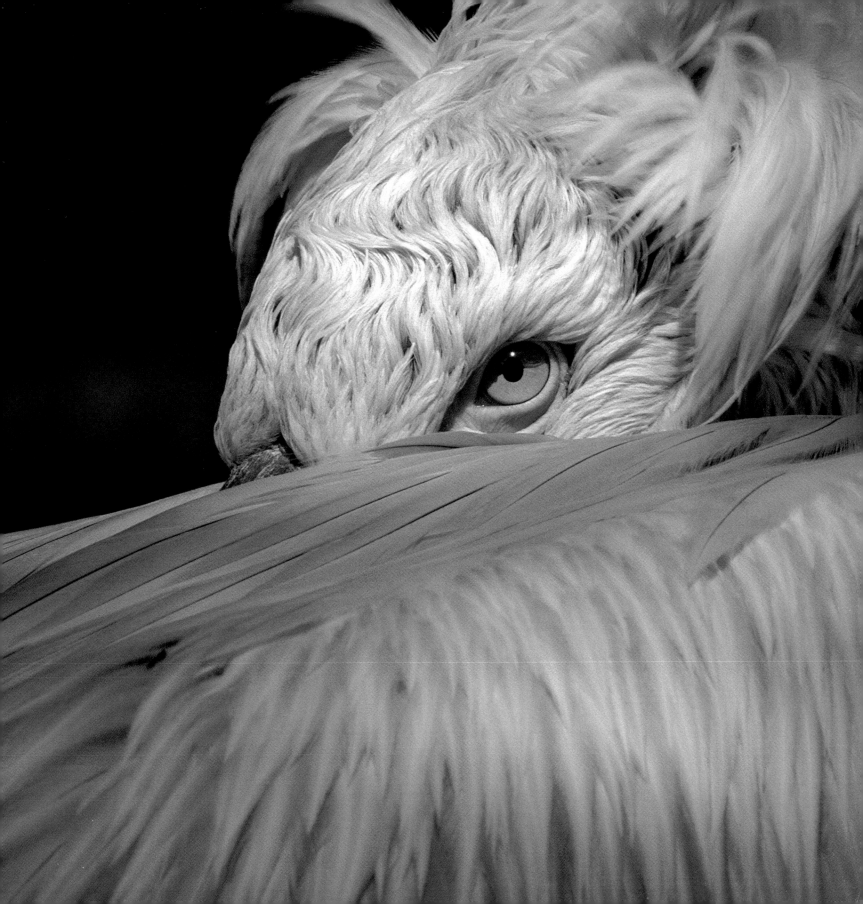

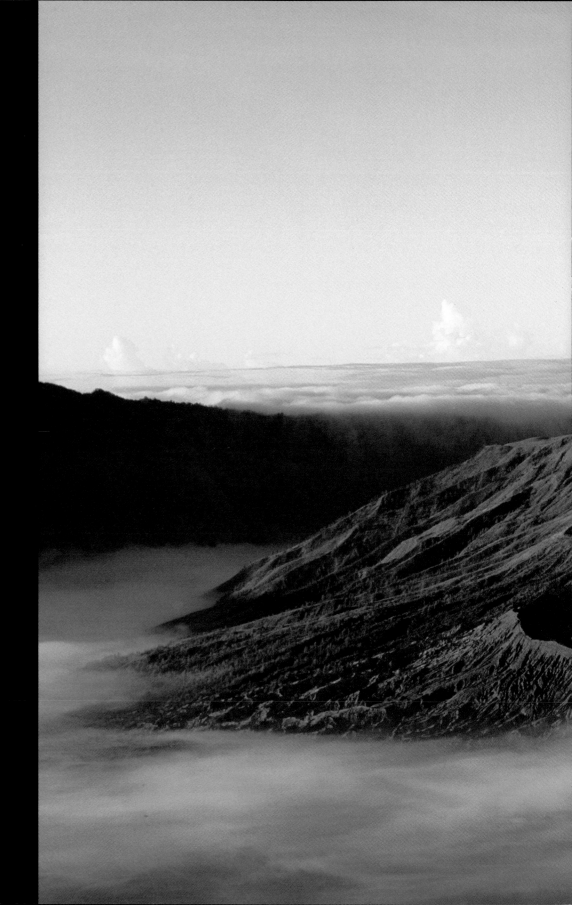

Mount Bromo, Java
DAN BROOKS

These are active volcanoes of the Tengger region of East Java, Indonesia. Sitting in the remnants of a massive caldera are the central crater of Mount Bromo, with the more complete Mount Batok to the side. In the background is the highest mountain in Java, Mount Sumeru, which erupts every 30 minutes.

Canon EOS 1N with 28–70mm lens; 1/15 sec at f8; Fujichrome Provia 100; tripod.

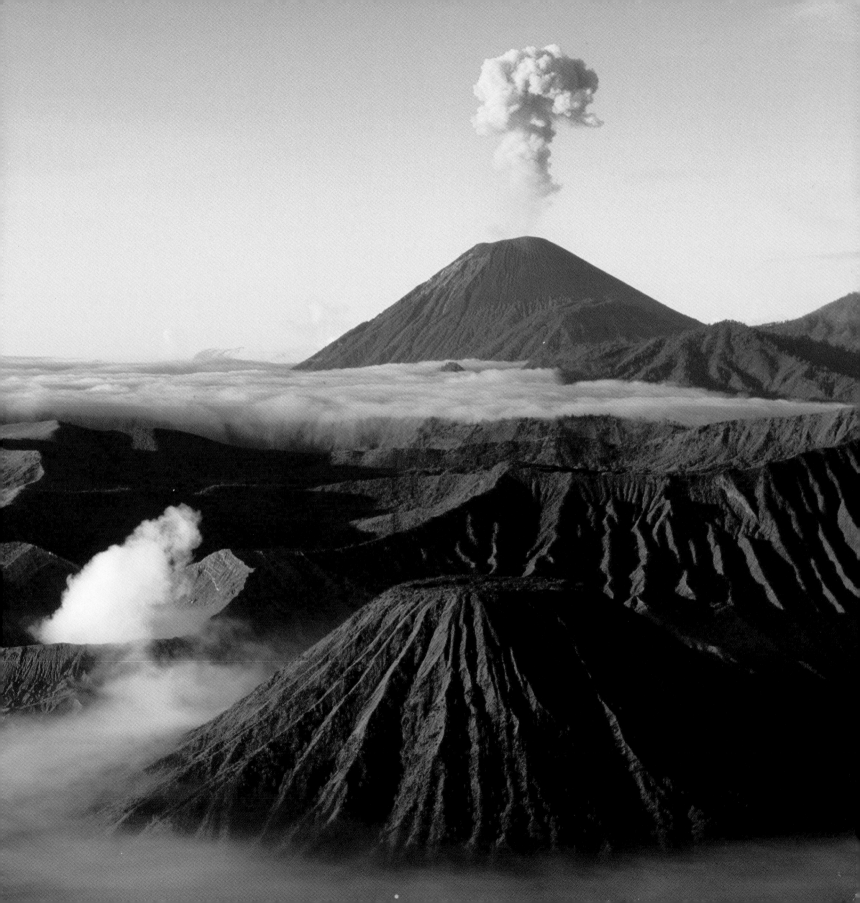

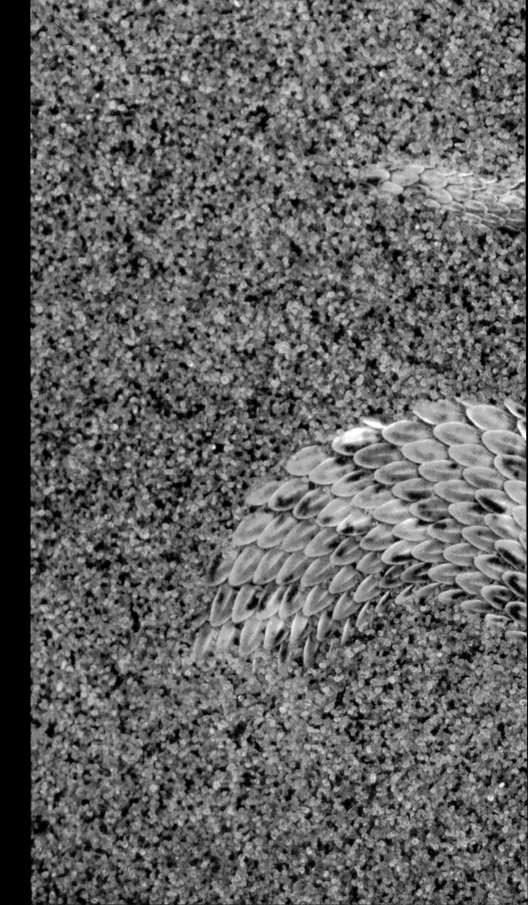

Peringuey's adder burying itself

THOMAS DRESSLER

The Peringuey's adder, or sidewinder, buries itself in the sand on the dunes of the Namib Desert, Namibia, to hide and to keep cool. Prey is lured in by the twitching of the black tip of the adder's tail. If animals such as lizards or geckos fall for the adder's trap and come too close, the adder will strike and release its poisonous venom.

Canon EOS 5 with 28–105mm lens at f6.7; Fujichrome Velvia 50.

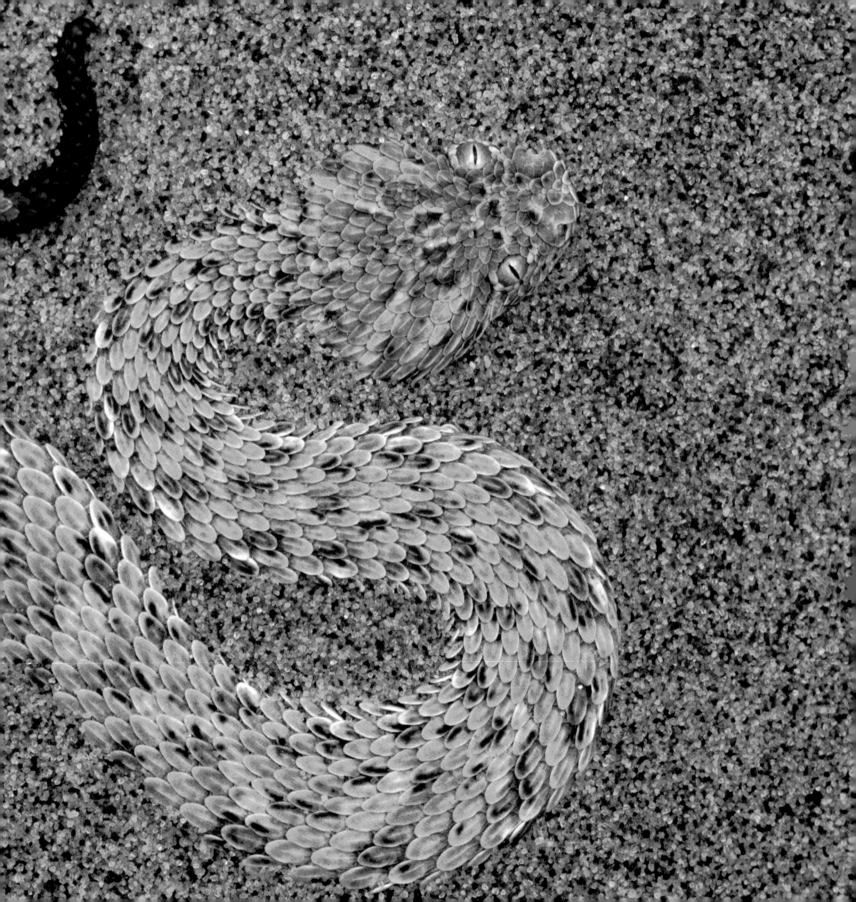

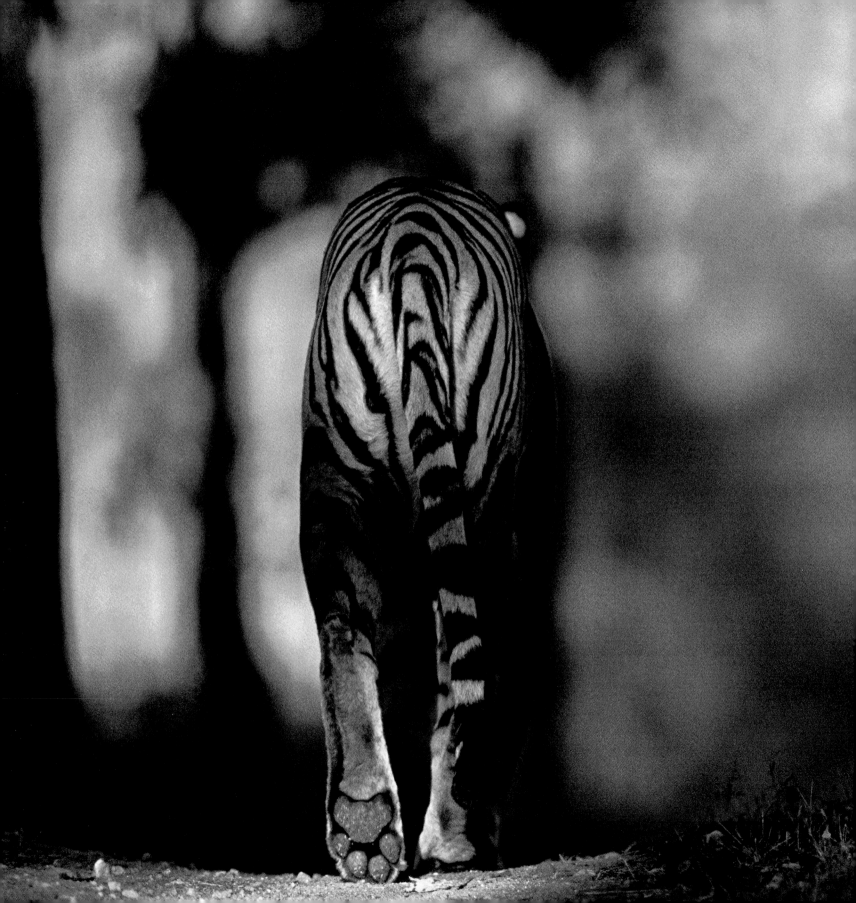

Bengal tiger on a forest track

NICK GARBUTT

'Tracking tigers can be frustrating. Usually it's a matter of following the alarm calls of other animals – langurs, chital deer, peacocks – and occasionally getting lucky. This magnificent young male was just strolling along the road one late afternoon in Kanha National Park, Madhya Pradesh, India. He didn't look back once. Then, right after this picture was taken, he lay down in the middle of the road. Five minutes later, he got up, walked straight past the jeep and, without a sideways glance, melted into the forest.' In India there are only about 1,400 tigers left in the wild.

Nikon F5 with 500mm lens; f4; Fujichrome Velvia 50 rated at 80; beanbag.

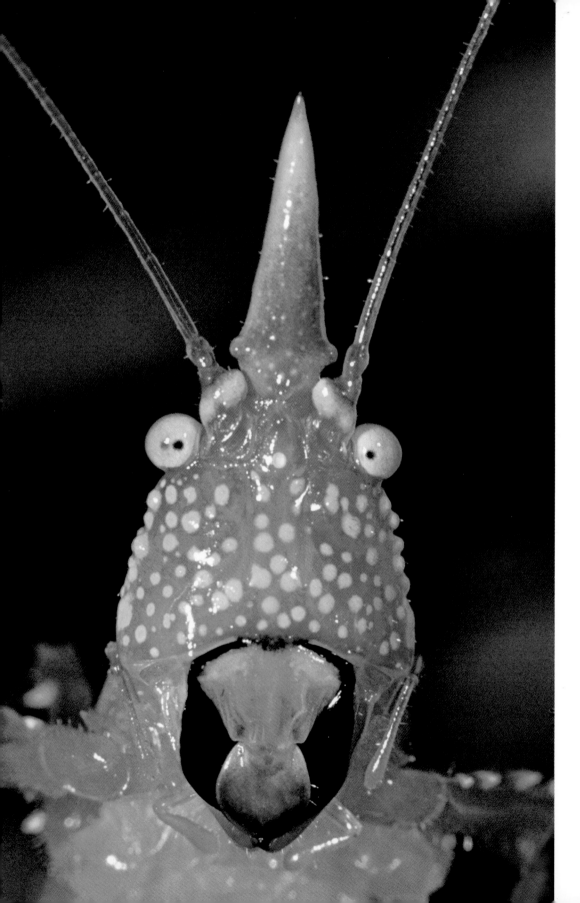

Young horned katydid

BRIAN KENNEY

'I found this horned katydid one night in the rainforest in Costa Rica. From the side, this insect seems to be a simple leaf imitator. Its bizarre appearance only becomes clear on close examination.' Brian caught the katydid because there was not enough light for him to take a close-up. He photographed it in the morning light the next day and then released it back into the wild.

Nikon 8008s with 105mm macro lens and extension tubes; flash; 1/250 sec at f16; Fujichrome Velvia rated at 40ASA.

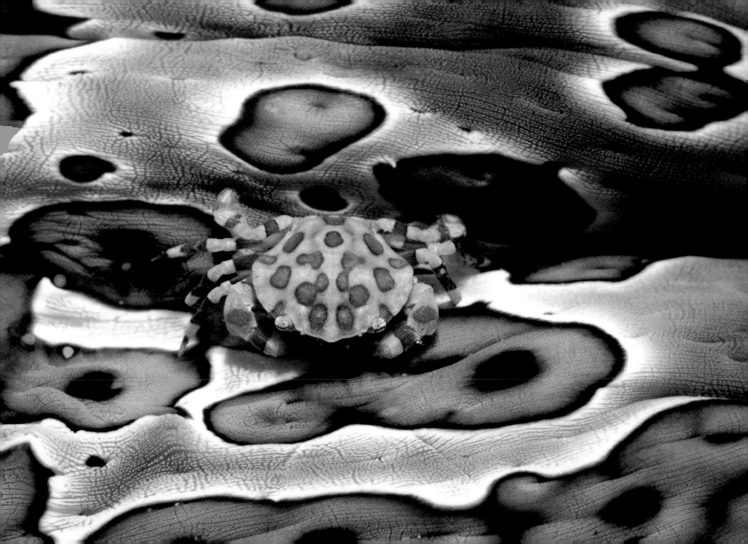

Giraffe family at sunrise
GABRIELA STAEBLER

'Twins are rare among giraffes, and so I don't know if these two youngsters in the Maasai Mara in Kenya were related. Sometimes a giraffe will babysit a youngster while its mother drinks or feeds, but I couldn't see any other giraffes nearby. When they left the woodland and headed towards the open plains, I positioned myself so that they were silhouetted against the red sky. Then I waited until the calves were on either side of the female.' Female giraffes give birth roughly every 20 to 23 months, usually to one calf, though very occasionally twins. Calves can stand on their wobbly legs within 20 minutes of being born.

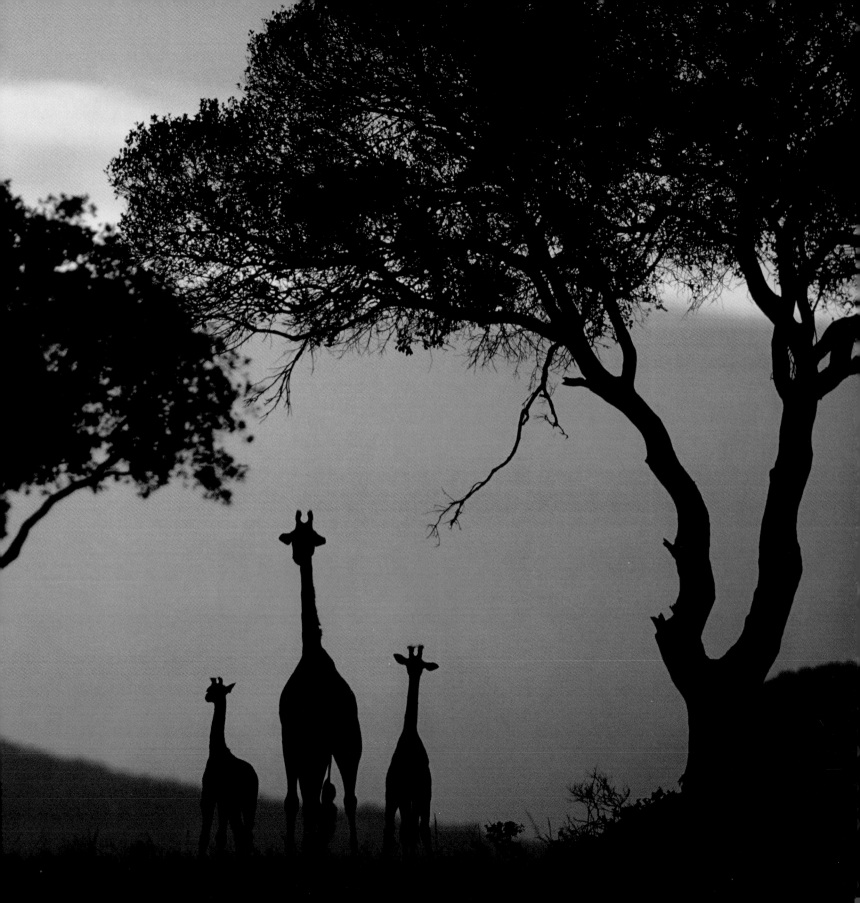

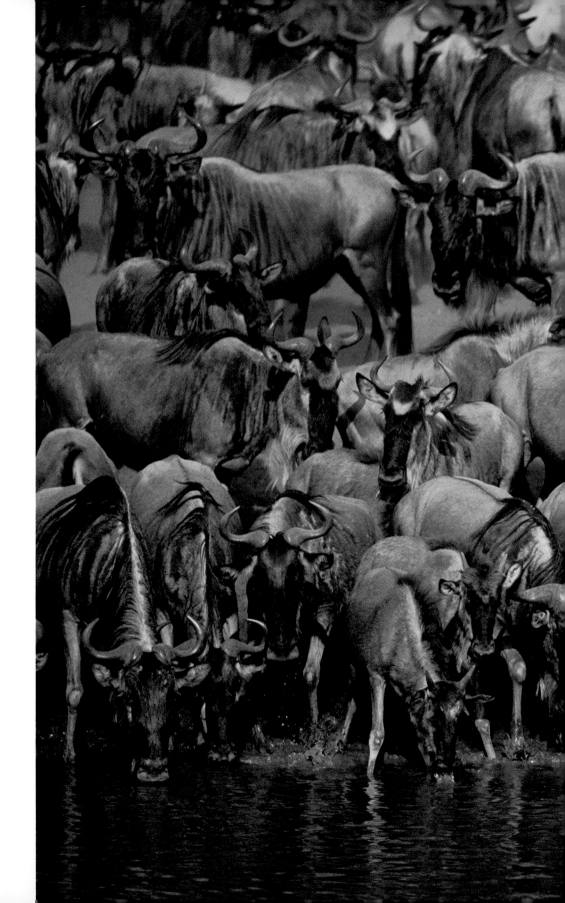

Crocodile attacking wildebeest

MANOJ SHAH

Every year around one and a half million wildebeest migrate across the Serengeti-Mara plains of East Africa in search of fresh grass. When the herds cross water or stop to drink they provide a rich source of food for Nile crocodiles. The location for this image is Grumeti River, Serengeti National Park, Tanzania. This crocodile has launched itself out of the water at the herd. Despite the crowds, its not a fool-proof manoeuvre – the crocodiles often miss.

Canon EOS 1N with 200mm lens; Fujichrome Sensia 100.

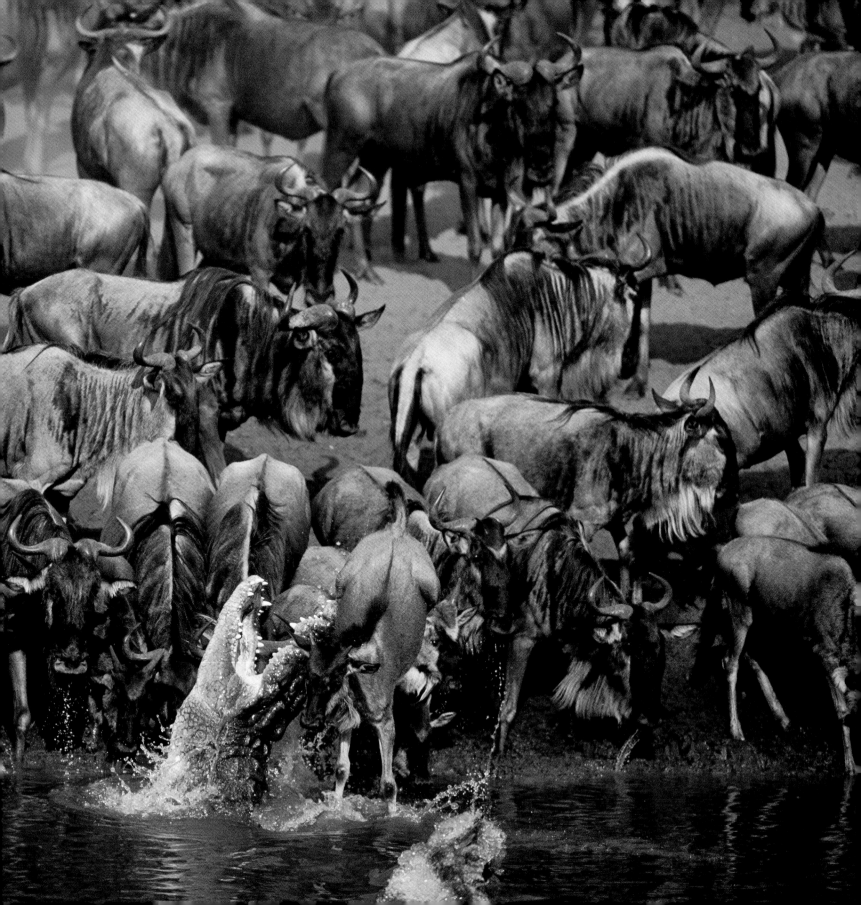

Golden jackal chasing flamingos

ANUP SHAH

At the centre of Tanzania's Ngorongoro Crater is Lake Makat, a shallow warm soda lake. Spirulina algae bloom in the lake in vast numbers which attract lesser flamingos in their thousands to come and feed. The birds in turn attract predators like hyenas and golden jackals. Anup watched this jackal target a bird before accelerating to pursue it, alarming the rest of the flock which took off in a flurry of wings and legs.

Canon EOS 1V with 600mm lens; Fujichrome Provia 100.

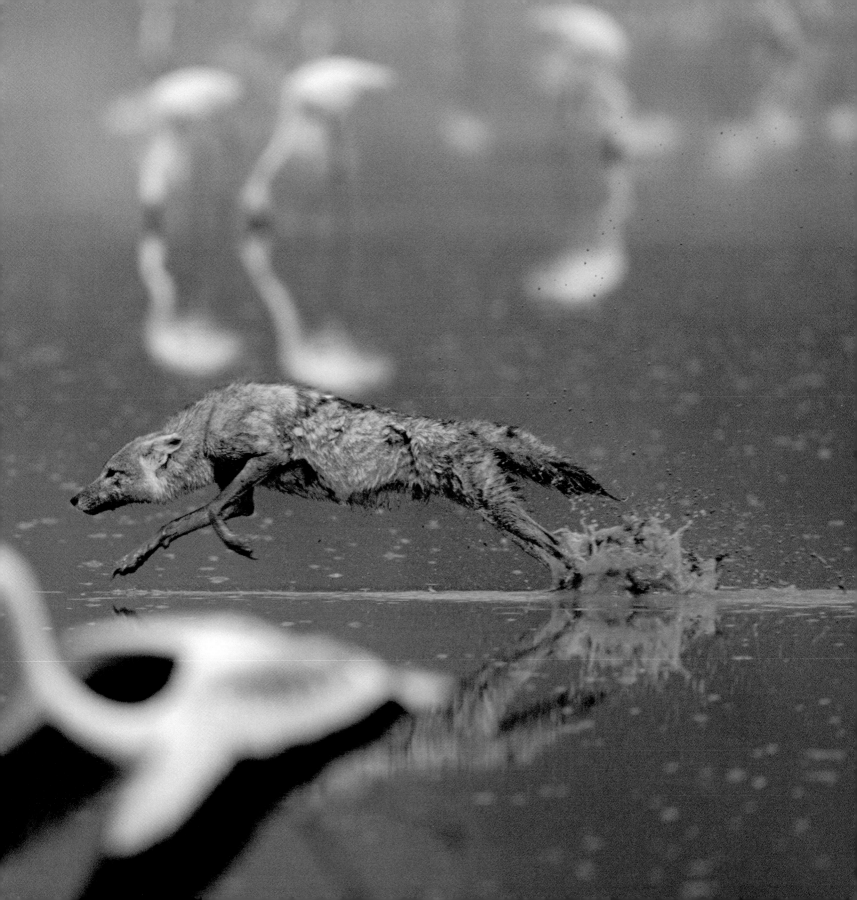

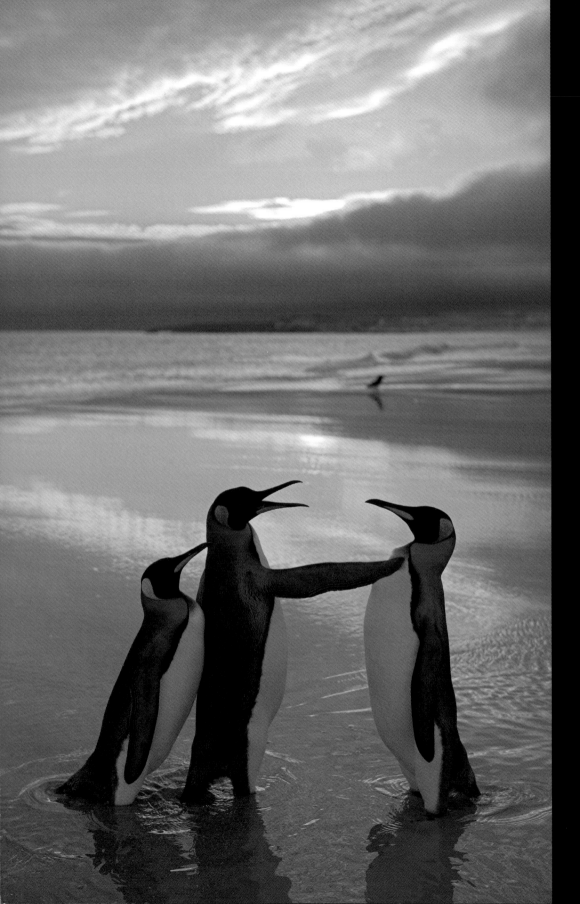

Rival kings

ANDY ROUSE

On Christmas morning on the Falkland Islands, Andy found this 'squabbling threesome' on the beach. 'I ended up spending four hours with them – their antics made me laugh so much.' The couple on the left were followed around all morning by this other male who refused to take no for an answer. Eventually the males slapped each other with their flippers, with the female sheltering behind her chosen mate. 'Kings are such cool penguins, I love photographing them and to hear their amazing clarinet style call is something I will never forget.'

*Canon EOS-1Ds Mark II with 24–70mm lens;
1/60 sec at f4; 200 ISO.*

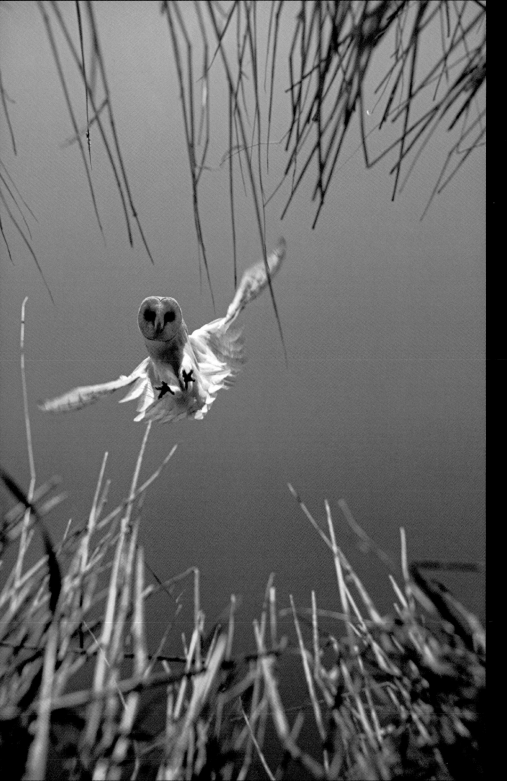

Barn owl hunting and hovering
NICK OLIVER

Nick watched this barn owl for hours as it hunted over rough grassland in Suffolk, UK. He got to know her habits intimately. 'I then set up a camera trigger and lure near a post she sometimes perched on. I focused the camera at the height at which I hoped she would hover. When the owl landed on the post, I tugged at a length of fishing line to twitch the lure. She leapt off the post and hovered above the camera, which I operated using a second line. Once she had satisfied herself that the lure was inedible, she flew off again and soon caught a vole.' Owls swallow everything – bones, fur and feathers. They then regurgitate all the rough bits in a compact pellet, sometimes containing the remains of several meals.

Minolta x-700, with motordrive and 28mm Tamron lens; 1/250 sec at f11; Fujichrome Provia 100 rated at 200; Manfrotto tripod head fixed to a wooden peg; remote trigger made from perspex; nail and fishing line.

Clash of the elephant seals

TIM FITZHARRIS

'At point Piedras Blancas, California, I watched and photographed an elephant seal colony for a couple of hours one morning. Suddenly, a fight erupted between two mighty males about 100 metres away from me in the big surf. I quickly moved closer and began shooting. The lighting and breaking waves were perfect. The bulls were incredibly violent with each other, though neither was seriously hurt after the 10-minute match.' Northern elephant seals symbolise a true conservation success story. They were hunted to the brink of extinction in the late 1800s, but the population has slowly recovered. They are now fully protected within their rookeries in Mexico and USA.

Canon EOS 3 with 500mm lens plus Canon Teleconverter 1.4 x; 1/500 sec at f8; Fujichrome Provia RDPIII.

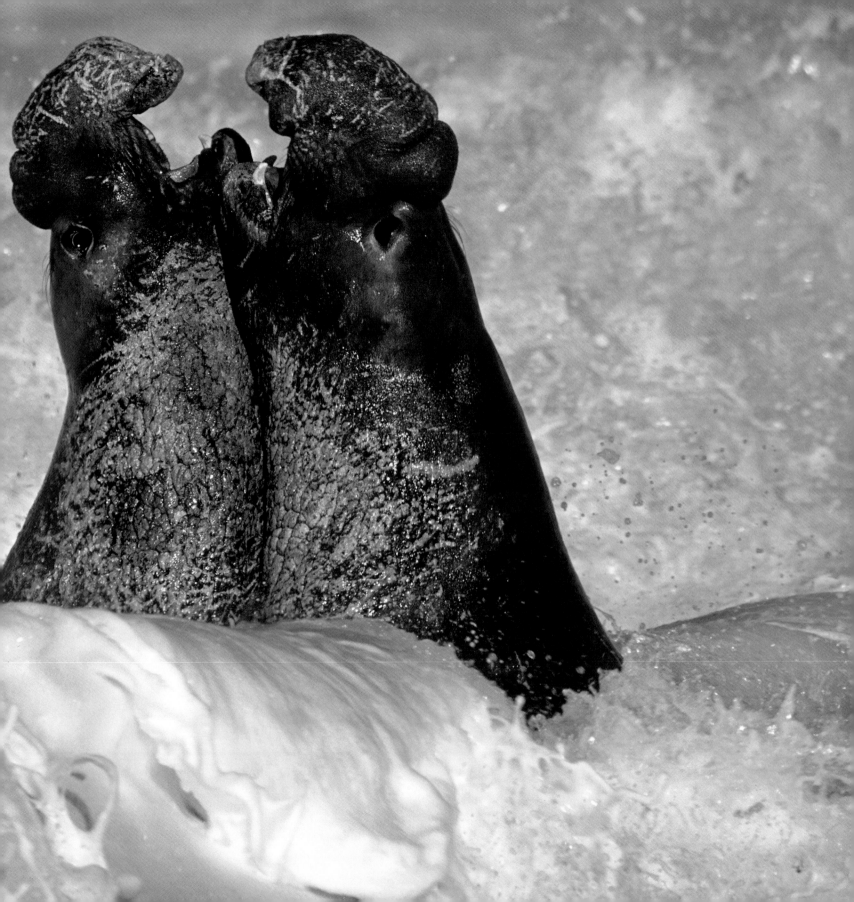

Red fox in winter

BENCE MÁTÉ

Red foxes are usually nocturnal but the severe winter meant that this adult, photographed in Hungary, was forced to hunt for food in the daytime. 'It pounced into the low snow-bank in the foreground, desperately trying to catch a mouse. In between taking photos, I had to remove the batteries from the camera and hold them in the palm of my hand to get them working again. The mouse escaped, and the fox soon moved on to search for food elsewhere.'

Nikon F100, with Nikon 300mm f2.8 lens; TC-301 x 2 teleconverter and TC-14b 1.4 x teleconverter; 1/125 sec at f2.8; Fujichrome Velvia.

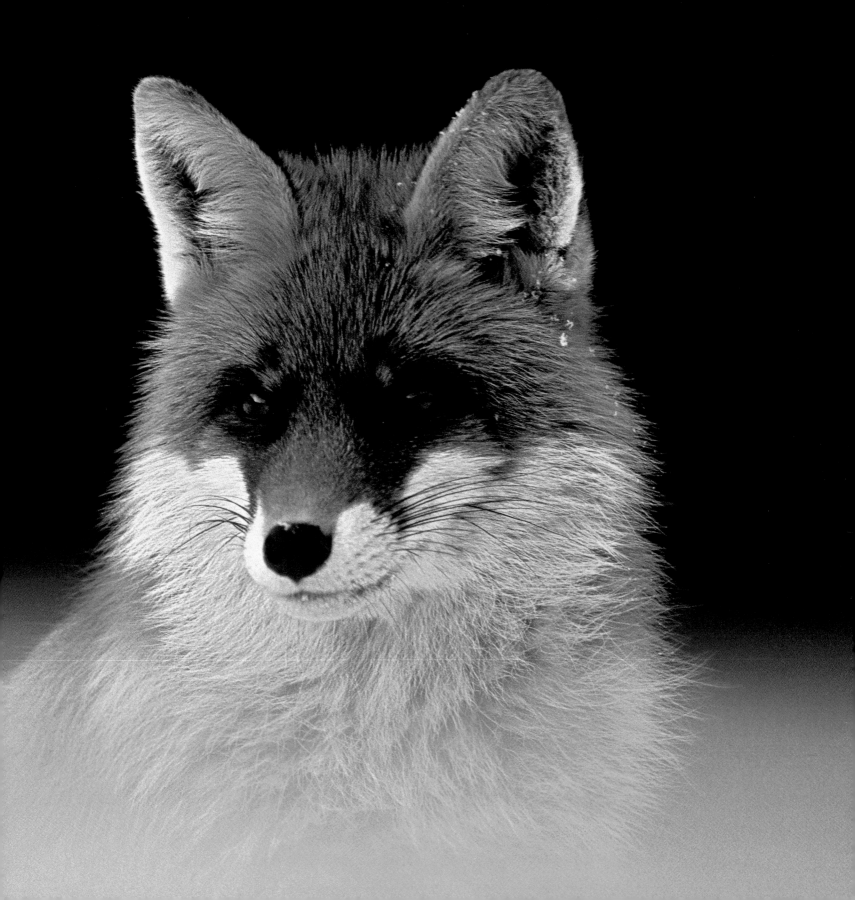

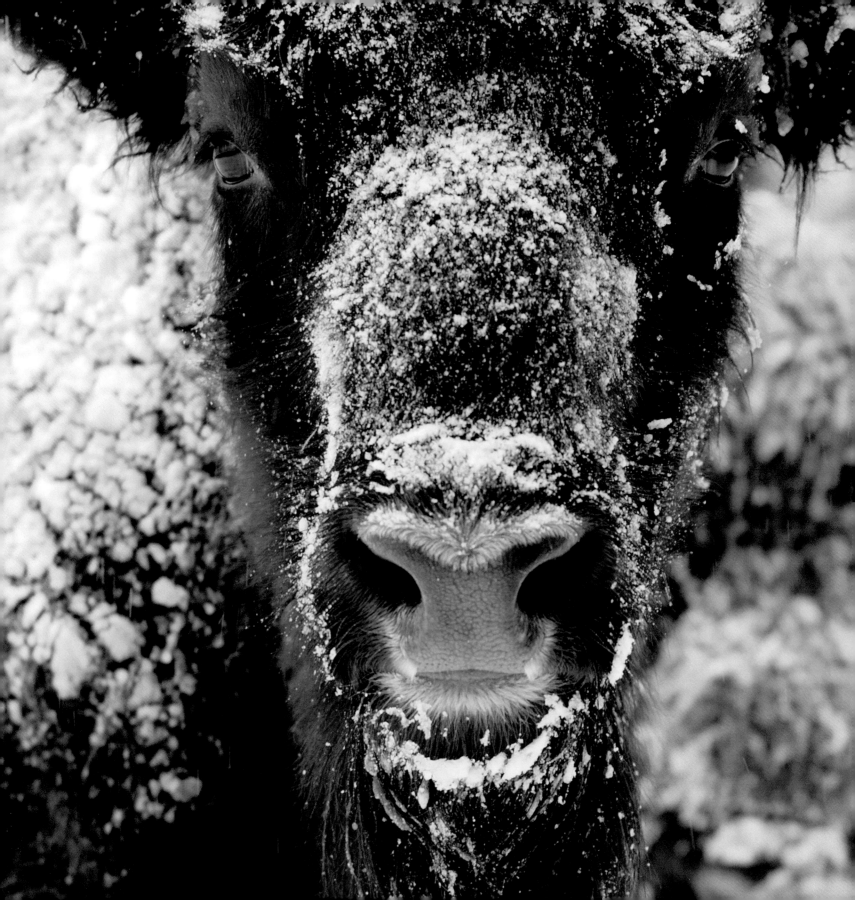

Cold and curious bison

KLAUS NIGGE

'I took this photo in Bialowieza Forest, Poland, where the animals are truly wild and difficult to get close to. I set up a hide in a clearing where they feed. This group arrived in the early morning after a night of heavy snow. They couldn't see me, but they were obviously aware of something unusual and stared intently towards the camera.' The European bison once roamed through most of Europe but by 1921, after extensive hunting, they became extinct in the wild. After World War II, a breeding programme was established and now 24 herds live across Eastern Europe.

Nikon D100 with 80–200mm lens; 1/90 sec at f4; digital 200 ISO.

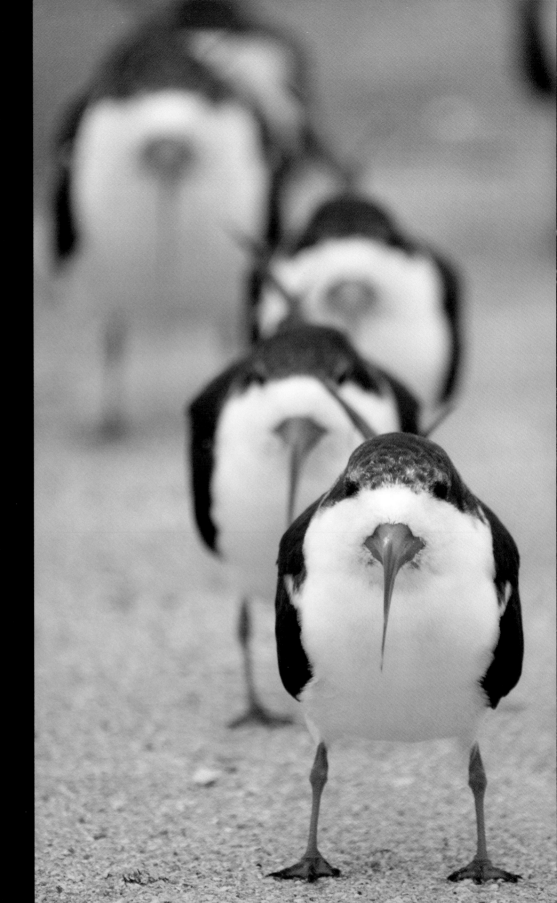

Skimmers on show

EVAN GRAFF

Black skimmers are one of Evan's favourite birds; these were photographed on Merrit Island, USA. 'When I saw a flock resting on the island, I dropped to the ground and inched closer by crawling on my stomach. I positioned myself so I could see several birds behind one another, all facing the same way. Their bills look really big from the side, but I wanted to show how thin and delicate they really are.' Skimmers get their name from the way they feed. They fly low over the water with their elongated lower mandible just cutting through the surface. Any small fish in the way of the bill are snapped up instantly.

Nikon D200 with Sigma 50–500mm EX lens; 1/320 sec at f6.3; ISO 400; tripod.

Rockhopper rush-hour

SOLVIN ZANKL

Solvin spent a month in the Falkland Islands, near the southern tip of South America, getting to know the rockhopper penguins well. When the rockhoppers returned from feeding at sea, they hurried out of the water and across the beach on Saunders Island to their nests in large numbers. They were trying to avoid the leopard seals and killer whales that hunt around landing or departure areas. At first Solvin tried to photograph the rush-hour in bright sunlight, but the shadows on the white sand were distracting. Getting the right photo was all about timing.
'I had to wait for the right mix of low tide, indirect sunlight and, of course, a big enough group of penguins. When these ones made a dash for the beach, my finger was ready on the release.'

Nikon D2x with 400mm f1-2.8D lens; 1/320 sec at f6.7; 1.4x converter.

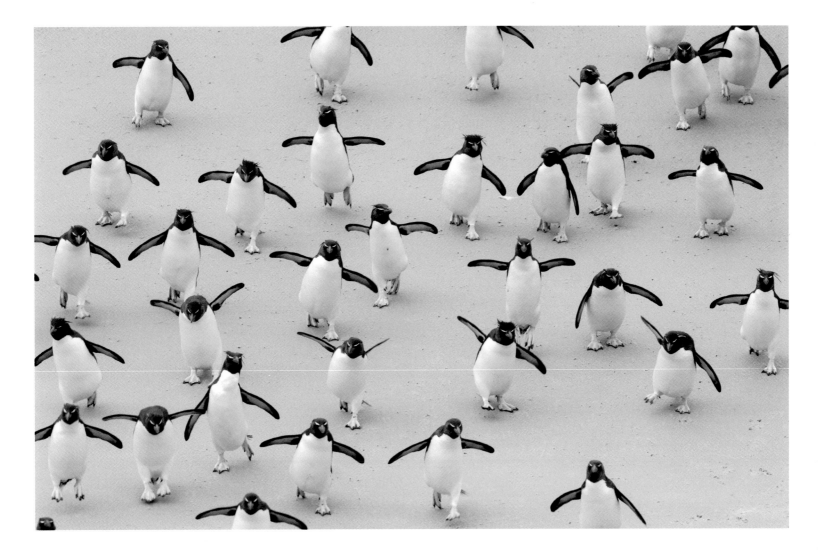

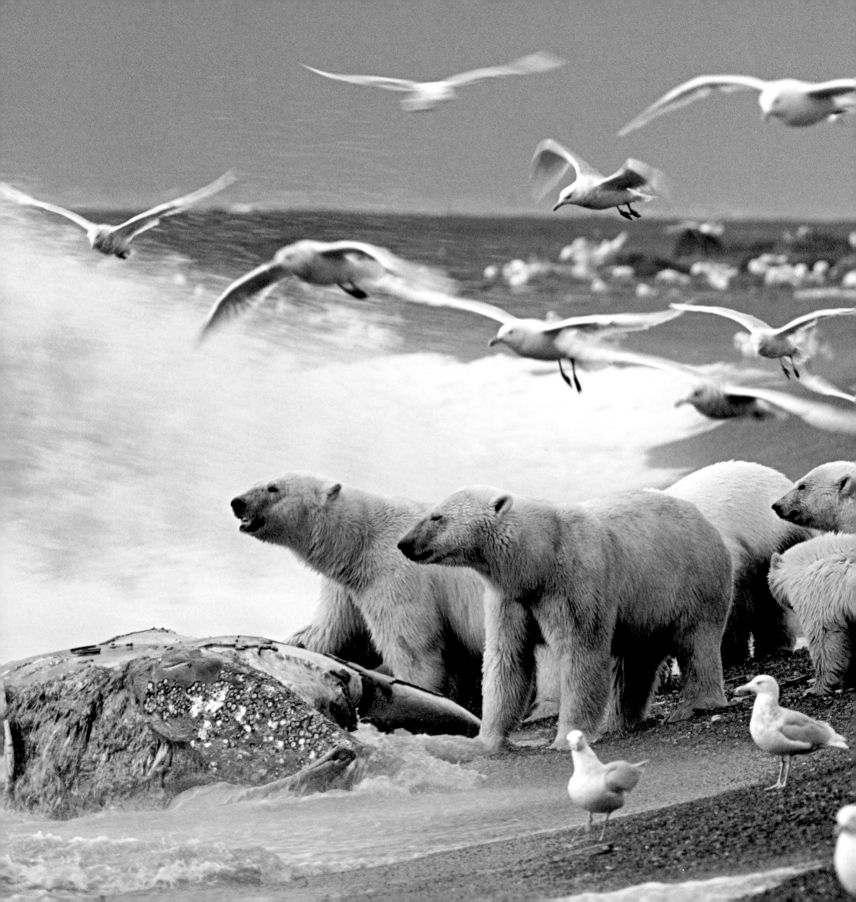

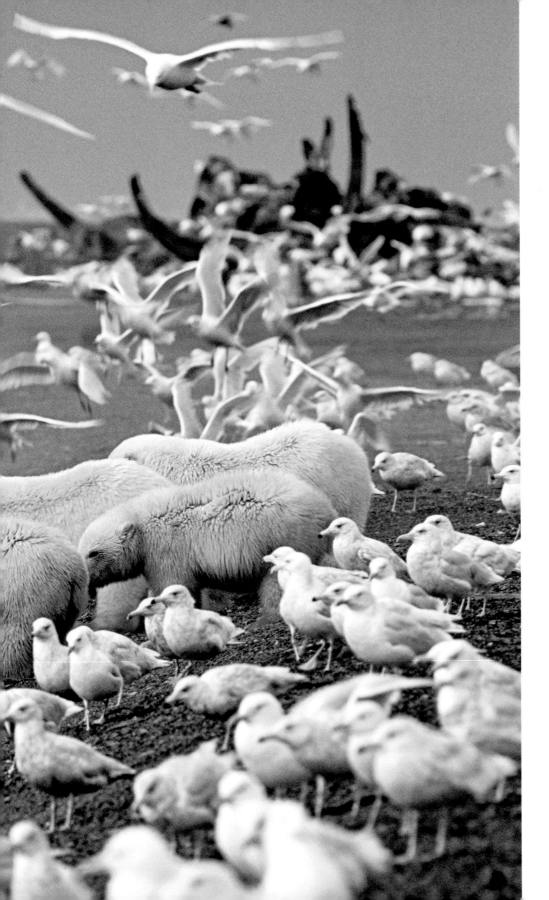

Polar bears scavenging

HOWIE GARBER

On the coast of the Chukshi Sea, northern Alaska, a grey whale corpse lured in a surprising crowd. Usually, polar bears are solitary but this group contained adult males, at least one female, sub-adults, yearlings and cubs. Another 30 or so bears waited their turn. As a result of climate change, the sea-ice has retreated record distances from the coast in recent summers. This might explain the unusual gathering as many of these bears could have been stranded far from the ice and their usual prey.

Nikon F5, with 500mm Nikkor f4 lens; 1/500 sec at f5.6; Fujichrome Provia 100; Gitzo tripod.

Climbing coconut crab

JAN VERMEER

Jan was taking photographs for the World Wide Fund for Nature on the island of Aldabra, in the Indian Ocean, when he saw this crab. He was particularly struck by the vivid colours of the scene. 'The strong sun and sharp contrast were perfect for revealing just what a magnificent animal this is.' The coconut crab is a hermit crab, but unlike other crabs it doesn't grow or borrow a shell. Instead it grows a hard skin as it matures, allowing it to just keep growing – making it one of the largest arthropods on land. From the tip of one leg to the tip of another it can grow to be one metre wide. It is also armed with pincers strong enough to crack a coconut.

Nikon D2x with 12–24mm f4 lens; 1/125 sec at f11; 200 ISO.

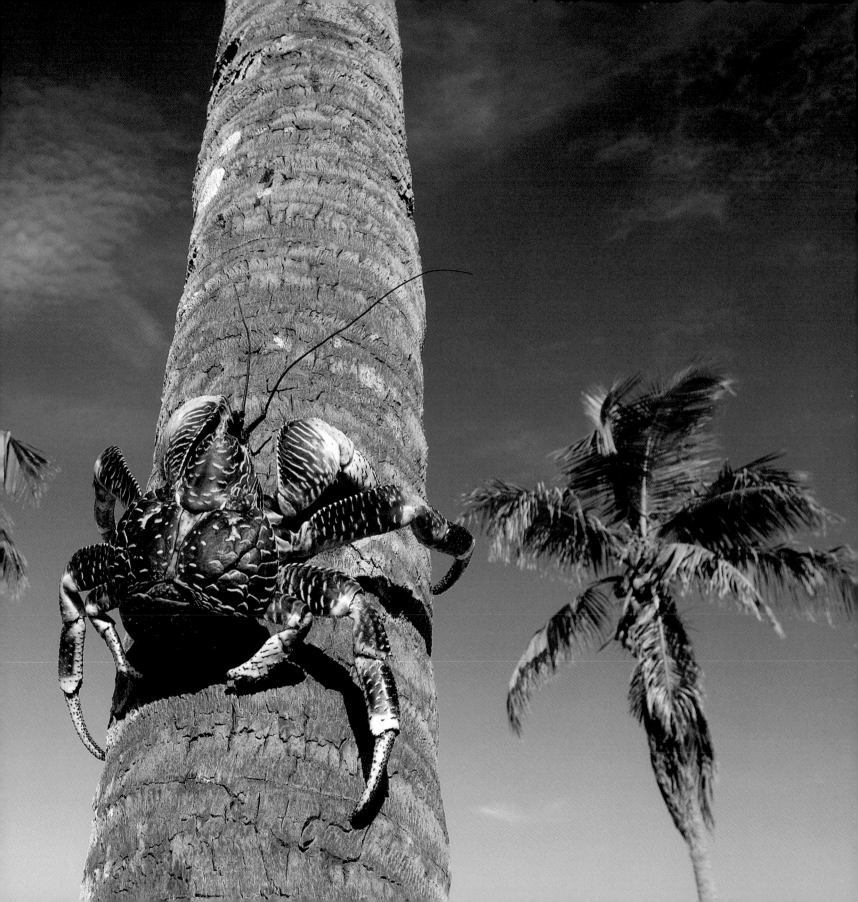

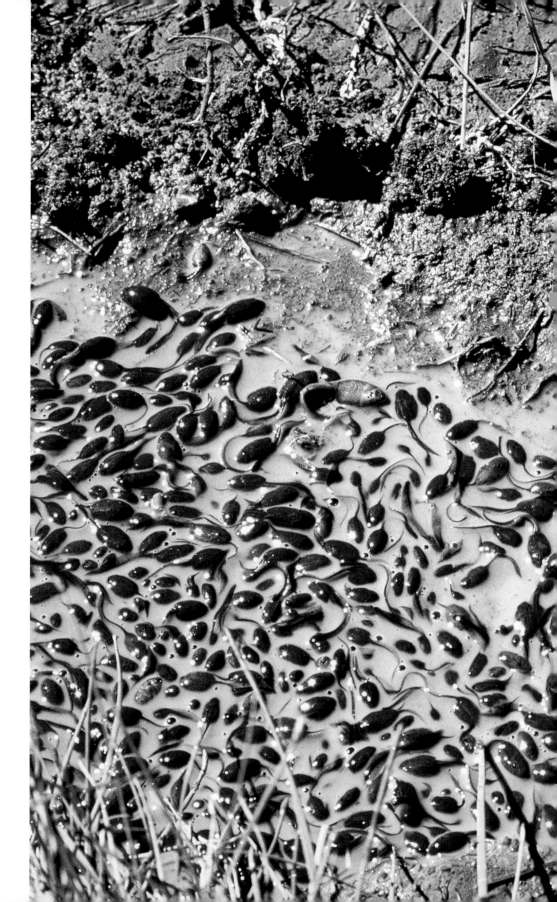

Giant bullfrog comes to the rescue

MARK PAYNE-GILL

This giant bullfrog in South Africa is digging a canal through the thick mud to try and save his offspring. The school of tadpoles have become stranded from the main pond and are at risk of drying out and dying. 'Such was the apparent strength of the bond between him and his tadpoles, he even leaped a metre out of the water, jaws agape, to "attack" me when I got too close to his charges. Five hours later, with little water left, the dam finally burst and more than a thousand tadpoles vigorously swam to freedom.'

Olympus OM2n with 100mm lens; 1/250 sec at f8; Fujichrome Provia 100.

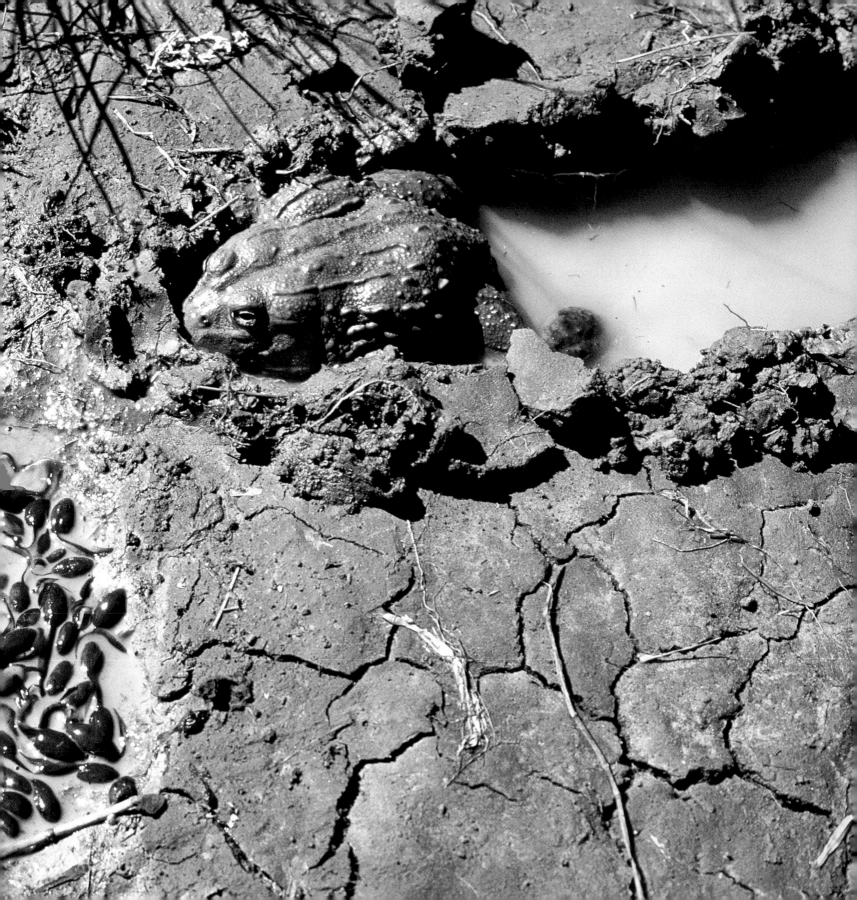

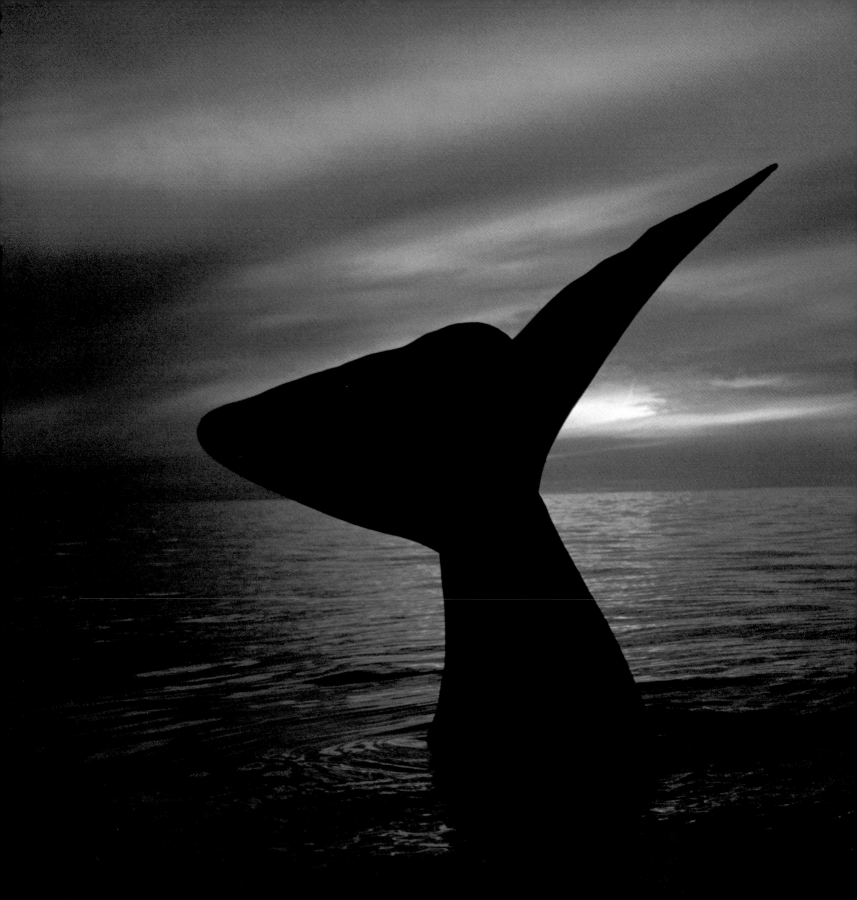

Southern right whale fluke

ARMIN MAYWALD

'I was so inspired after a whale-watching trip to the Valdes Peninsula in Argentina that I immediately planned my return visit. I couldn't get over seeing southern right whales doing "head-stands" – waving their flukes high out of the water for up to two minutes.' When Armin returned a year later it took five weeks to capture this shot of a whale head-standing against a magnificent sunset. No one is quite sure if the whales are playing, communicating or controlling their temperature.

Nikon F4 with 35–70mm lens; 1/30-1/60 sec at f2.8; Fujchrome Sensia II 100 rated at 200.

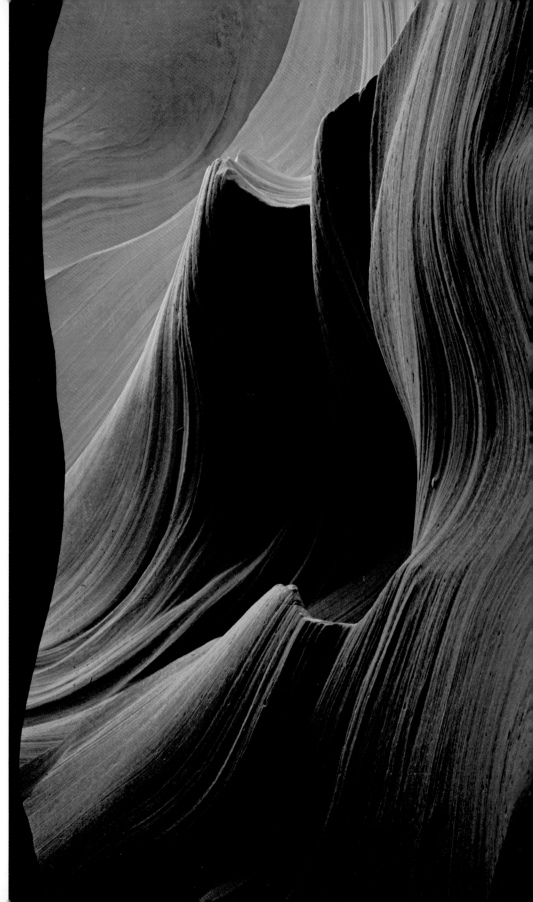

Sandstone canyon

MARK SUNDERLAND

The sandstone of Lower Antelope Canyon has been shaped by water over thousands of years. Even during the height of the Arizona summer, the bottom of the canyon remains cool and tranquil. 'On this sunny afternoon in late August, the swirling walls were illuminated by reflected sunlight. It seems strange that such a harsh environment can yield an image that looks almost soft to the touch.'

Deardorff with Schneider Symmar-S 150mm lens; 20 sec at f45; Fujichrome Velvia; tripod.

Flight of the mouse-eared bat

CARSTEN BRAUN

'After helping scientists catch and ring greater mouse-eared bats in a cave in Mayen, Germany, I photographed their release. The challenge was to set up the cameras, flashes and cables in the right place, in the pitch darkness with only a head-torch.' The greater mouse-eared bat spends four to five hours a day hunting insects in the air and on the ground, before returning to roost. Greater mouse-eared bats often use attics to rear their young though they prefer caves for hibernation in wintertime.

Canon EOS 5D + 70-200mm f2.8 lens; 1/200 sec at f16; ISO 100; four Canon 550EX flashes + light-beam sensor.

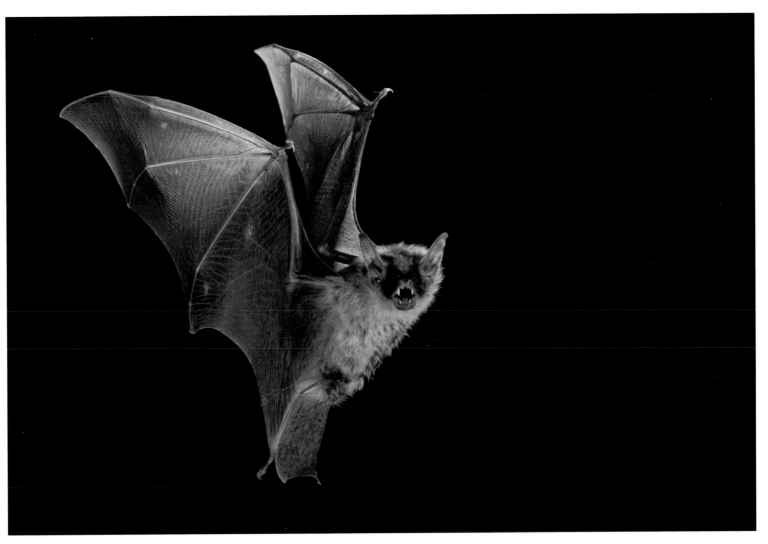

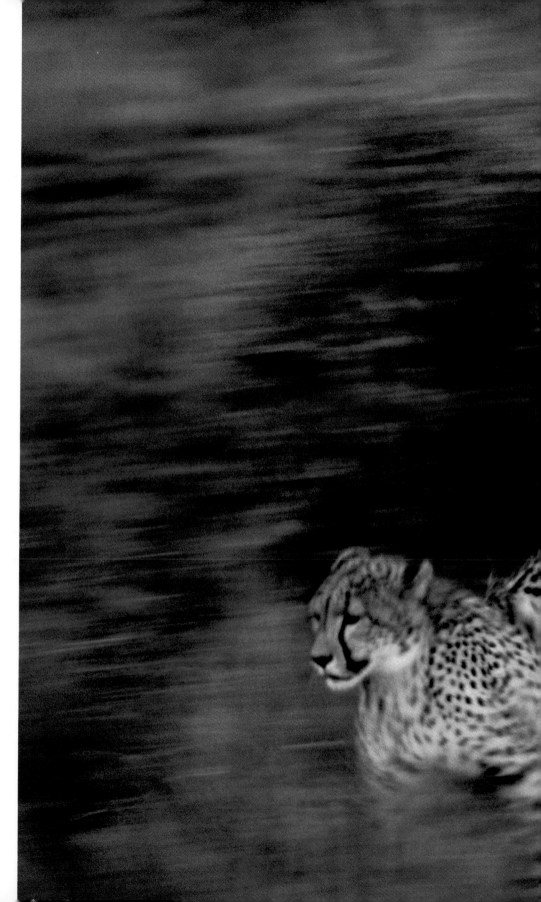

Cheetahs playing

GERALD HINDE

'I had been documenting the lives of these two sub-adult cubs and their mother in Phinda Game Reserve in KwaZulu-Natal, South Africa, for quite a time. While their mother was trying to hunt, the adolescents started to play-fight. Once their mother leaves them, the youngsters will stay together for at least six more months, and being males they may even remain hunting partners for life.' In the low light of the late afternoon, Gerald created the blurred effect by using a slow shutter speed.

Canon EOS 1V with 70–200mm lens; automatic setting; Fujichrome Velvia 50.

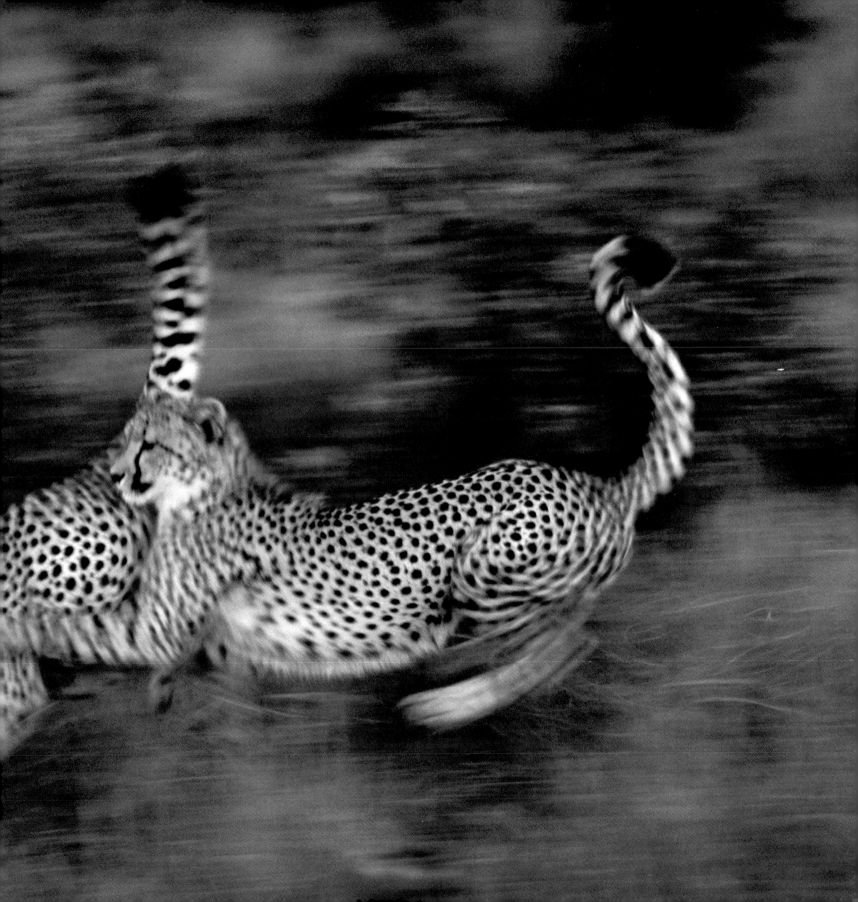

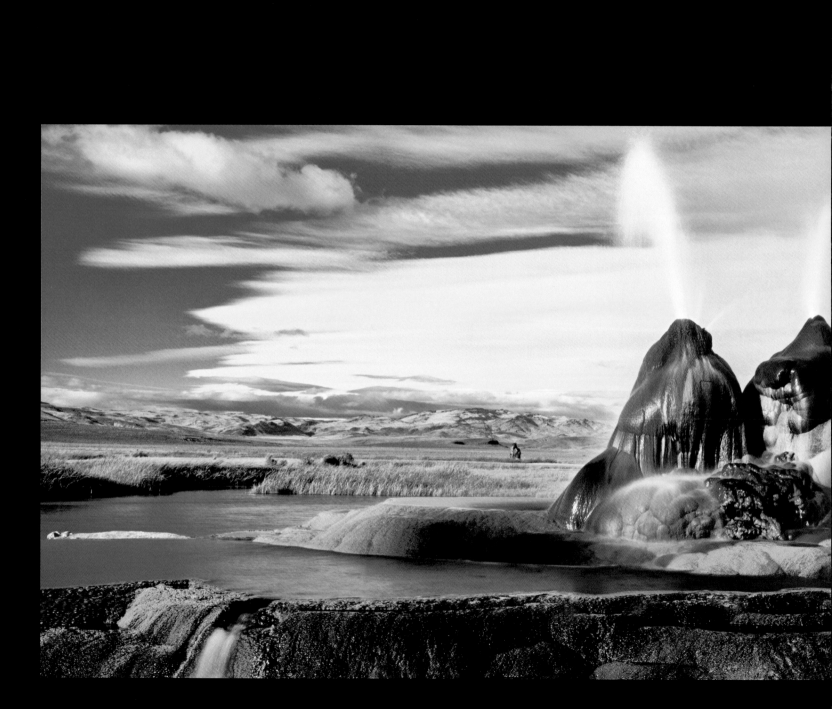

Black Rock Desert geysers

JEREMY WOODHOUSE

Northern Nevada in the western USA is famous for its hot springs and geysers. These drill-wells in the Black Rock Desert were probably made by people in search of water. They would have had a surprise when they hit this geothermal spring where boiling water continually spurts out under huge pressure. Over the years, mineral deposits have formed these cones and steps around the spring.

Fuji 617 with 105mm lens; 1/4 sec at f45; Fujichrome Velvia 50 rated at 40; polarising filter.

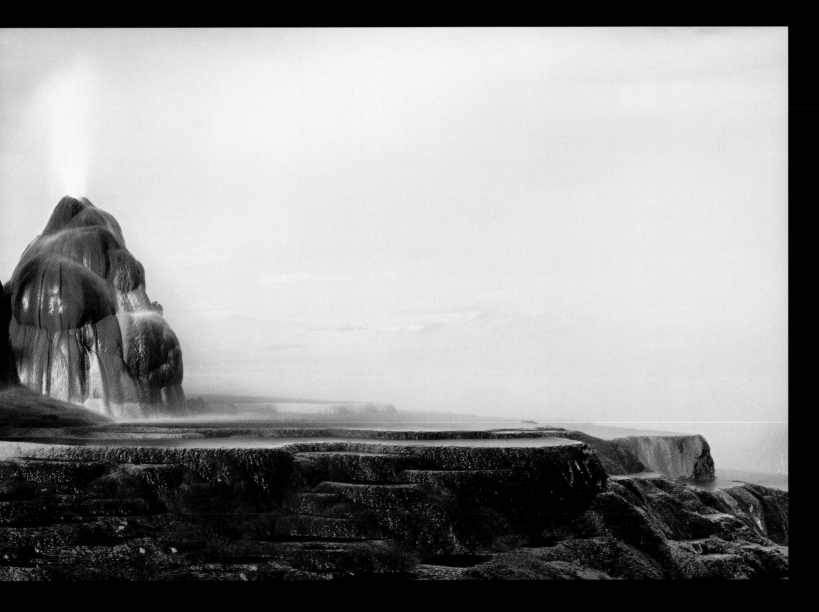

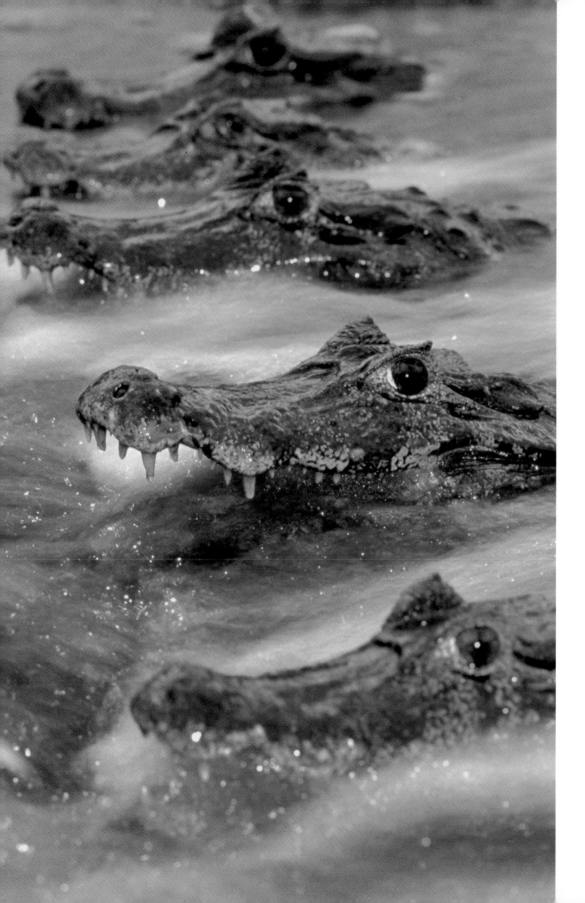

Yacare caiman ambush

MARK JONES

As dusk falls on the Pantanal Wetland, Brazil, the caimans wait, unmoving, with their jaws open. Fish are snapped up as the water flows across their teeth. 'Standing in the fast-flowing water at the outfall of a marshy lake in the world's largest wetland, I slowly approached this row of caimans. The beauty of slow-time exposure is that, while the camera does its thing, you have hands free to swat the industrial-strength mosquitoes.'

Nikon F5 with 300mm lens; Fujichrome Provia 100; tripod with ball head; strobe with fresnel lens.

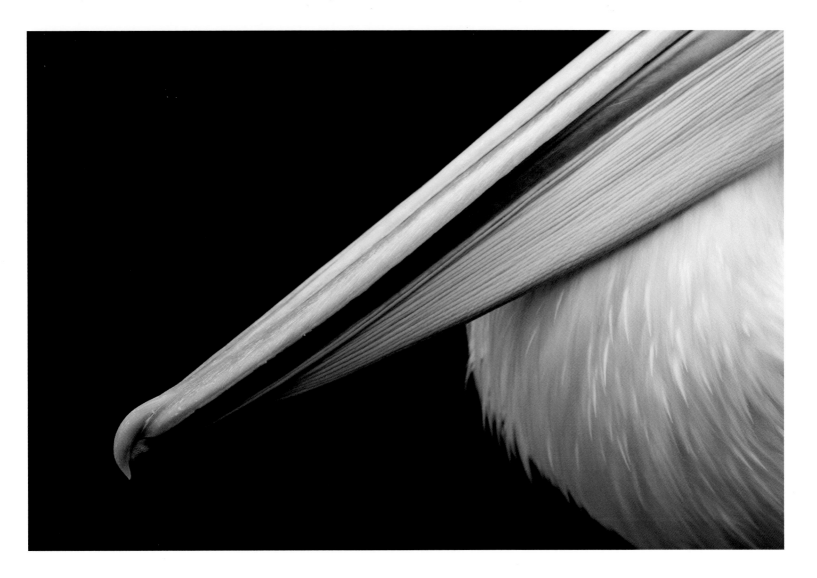

The pelican bill

WESLEY COOPER

'I was photographing birds when I became fascinated by this common Australian pelican. I watched for nearly half an hour as it cleaned itself with its beak, a process that involved turning the pouch inside out. By concentrating on the bill, I wanted to capture the spirit of the species.' There are seven known species of pelican and this one has the largest bill in the world. The bill is sensitive, which helps the bird to locate fish in murky water. The hook at the end is probably used to grip the fish while the pouch is used like a net to scoop food up.

Canon EOS 1D Mark II N + Canon EF 300mm f4 USM IS lens; 1/3200 sec at f4; ISO 320.

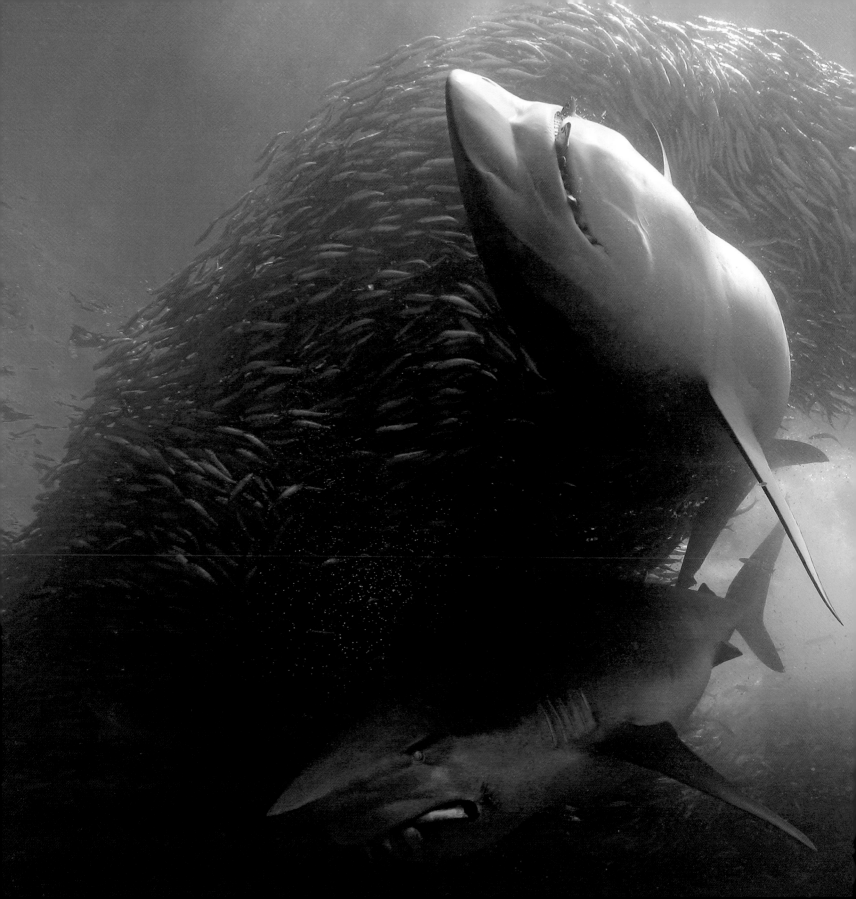

Sharks' sardine feast
DOUG PERRINE

Every year, huge shoals of sardines migrate up the east coast of South Africa. Doug was about a kilometre out to sea, off the Wild Coast, Transkei, when he saw the sardines being driven to the surface by a pod of common dolphins. 'Other predators soon rushed in, including tuna, birds and thousands of sharks. The bronze whaler sharks charged through the baitball, sometimes shooting clear out of the water with their mouths stuffed full of fish. They were so intent on feeding that they often bumped me as they rushed past. It was one of the most intense experiences of my life.'

Canon EOS D60 with Sigma 14mm f2.8 lens; 1/800 sec at f5.6; digital ISO 200; Canon 550EX strobe; UK–Germany underwater housing.

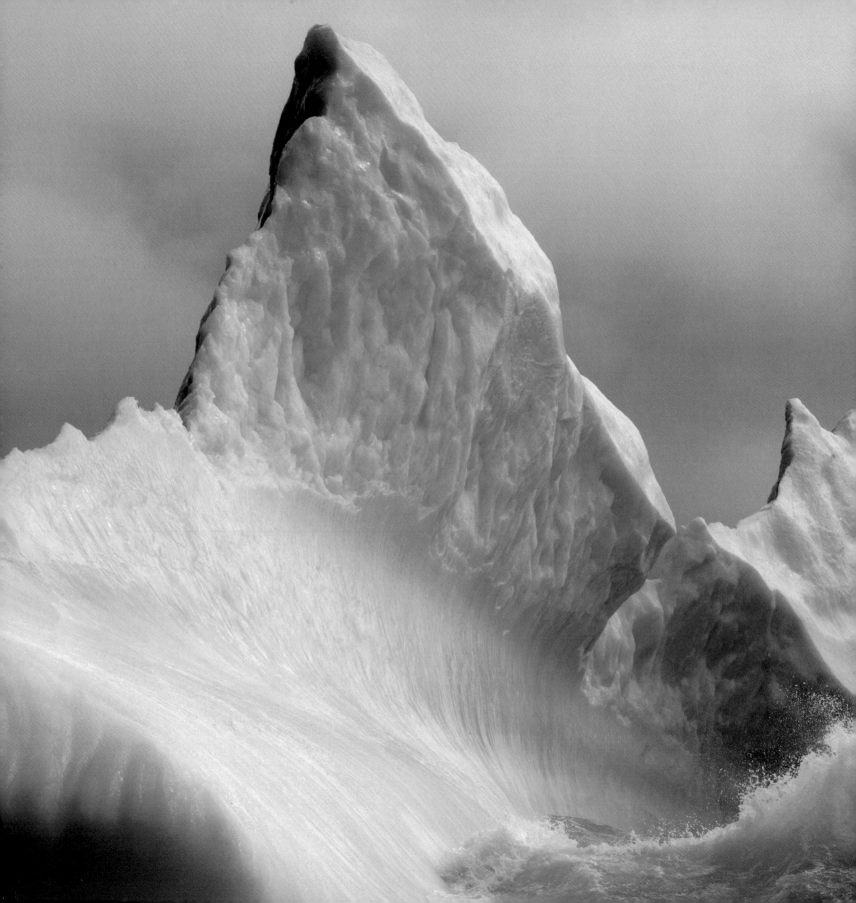

Ice creation
ROBERT KNIGHT

'The sea around South Georgia, off Antarctica, is full of icebergs, broken off from the huge glaciers down there. From our boat one day we saw this beautiful formation of cyan-blue pinnacles and ridges. The challenge was to capture something of the beauty and wildness of the scene, while waves buffeted the boat and spray covered me.' Icebergs are made from snow that has fallen over thousands of years and then been compacted into ice. At any one time there may be 300,000 icebergs in the Southern Ocean, pushed along at up to 40 kilometres a day by wind and ocean currents.

Canon EOS 1Ds Mark II with 70–200mm f2.8 IS lens; 1/800 sec at f13; ISO 200.

Great raft spider

TORE HAGMAN

Tore came across this raft spider in Komosse, a large peat bog in southern Sweden protected by the Ramsar Convention on Wetlands. 'The perfect setting for the magnificent creature was provided by an iron ochre sheen on the water. My biggest problem was that the longer I spent trying to compose the perfect picture the deeper my tripod and I sank into the quagmire.' Great raft spiders can catch large insects, small fish and even small frogs. Females can have bodies more than two centimetres long and a leg span up to seven centimetres.

Pentax 645 with 120mm macro lens; Fujichrome Velvia 50.

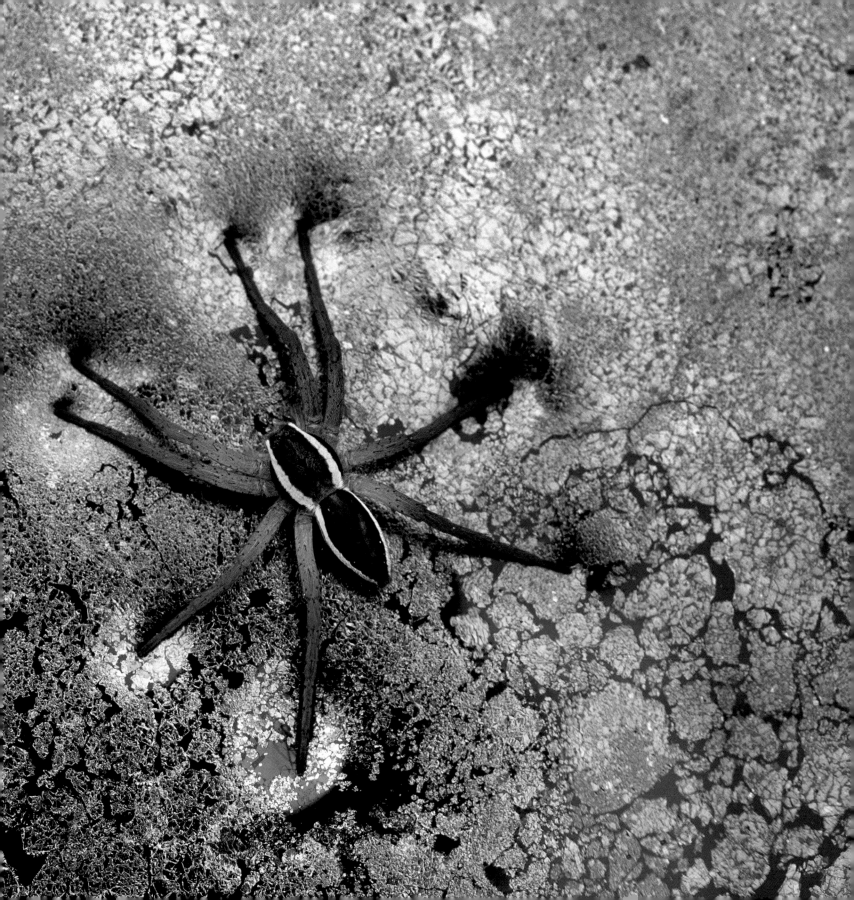

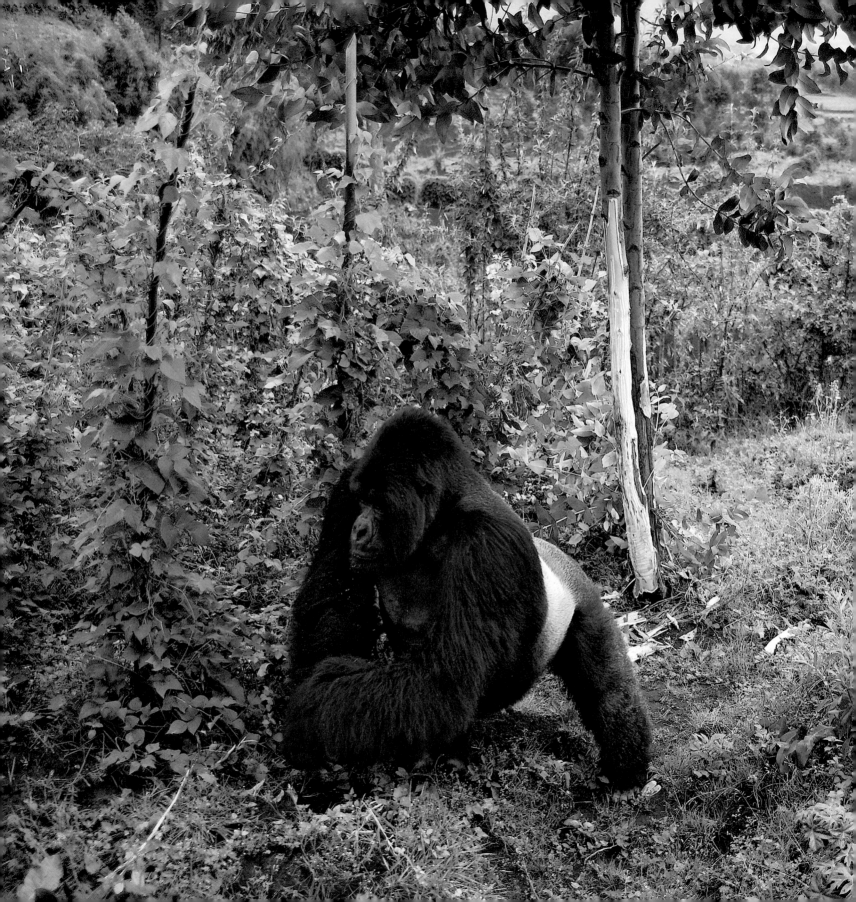

Silverback on the edge
JOE MCDONALD

On one of his many treks in the Volcanoes
National Park in Rwanda to see the
endangered mountain gorillas, Joe found
a troop before he had started climbing
the mountain, feeding in the papaya trees.
Some were fairly close to the village huts.
'I was struck by the symbolism of this image,
illustrating not only the loss of the gorillas'
habitat, but also how their future depends
on their relationship with the local people.'

*Canon 1Ds with Tamron 28–105mm f2.8
lens; 1/2000 sec at f2.8; 200 ISO.*

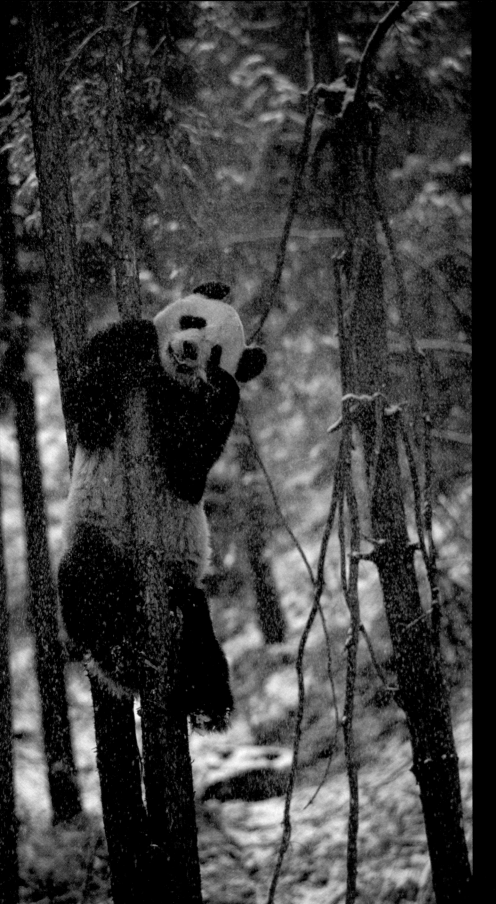

Captive giant panda exploring the wild

TOM SCHANDY

Xi Meng is a giant panda born in the Wolong Nature Reserve captive-breeding centre, in China's Sichuan Province. Here, she is out exploring the wild on her own. The centre aims to eventually return pandas to the wild to boost the population, but in the meantime it has one of the world's most successful captive-breeding programmes. Scientists there have pioneered breeding techniques which scientists from all over the world come to learn about.

Nikon F5 with Nikkor 80–200mm lens; Fujichrome Velvia; tripod.

Snake eagle family portrait
JOSÉ B RUIZ

For José, patience was the key to photographing this family portrait: 'I spent some weeks in a hide near this nest high in an Aleppo pine tree in Sierra del Coto, Alicante, Spain, in June, and was lucky to get this family together in one place. Short-toed eagles spend such a lot of time on the wing.' The male short-toed snake eagle has a smooth snake in its mouth for the hungry chick. The female has a twig to improve the nest. Sadly these domestic scenes are under threat from deforestation. Short-toed snake eagles prefer nesting in pine trees, which are being cut down to make way for expanding marble quarries.

Nikon F5 with 500mm f4 P IF ED lens; 1/250 sec at f4; Fujichrome Velvia 50; tripod, hide.

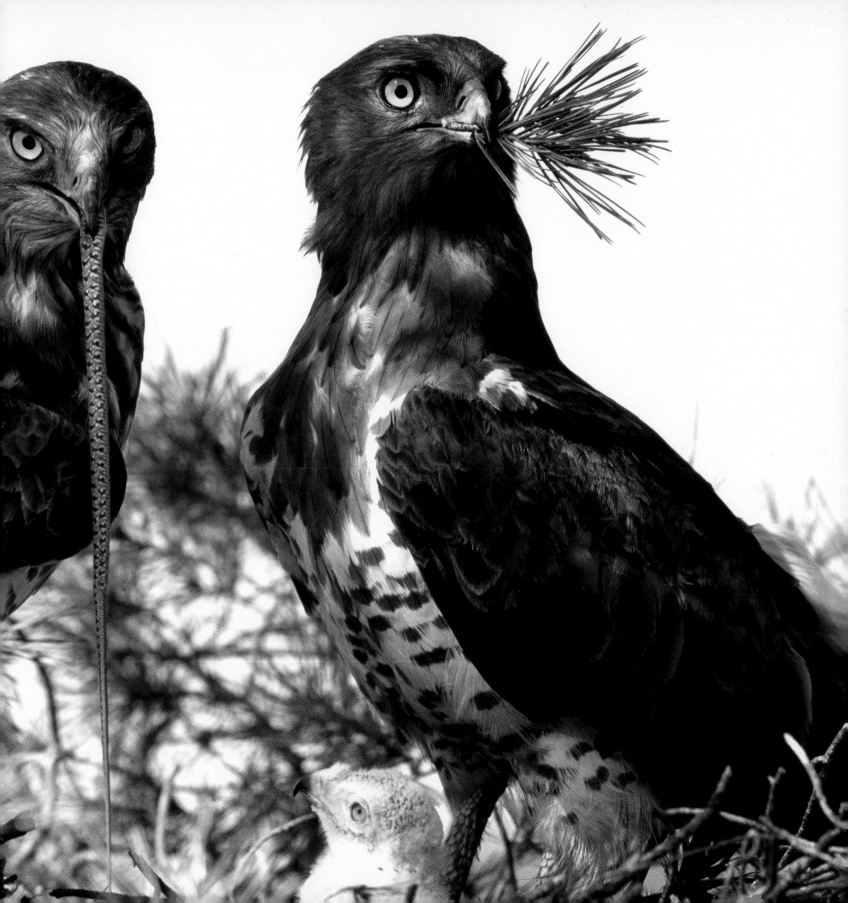

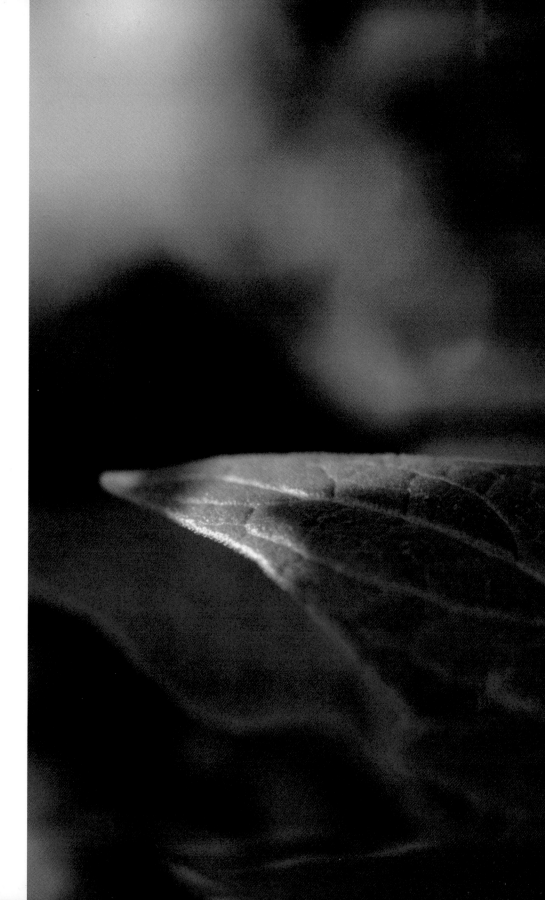

Camera shy green anole

GABBY SALAZAR

'I was scouting for insects in the Valley Nature Center in Weslaco, south Texas, when a flash of pink caught my attention. It was a male green anole displaying his dewlap – a large pink flap of skin on the underside of his neck – as a territorial "flag". As I approached, he retreated. He was only 12 centimetres long, so I needed to be very close for a photograph. I edged into position, avoiding the spines of a prickly pear cactus, and focused the camera. Then I waited for him to return. For me, this portrait sums up the essence of lizard.' Green anoles can change colour from bright tree-green to dark reddish brown. This one is blending in well with the leafy green background.

Nikon F5 with Nikon 70–180mm lens; f4.5-5.6; Fujichrome Provia 100.

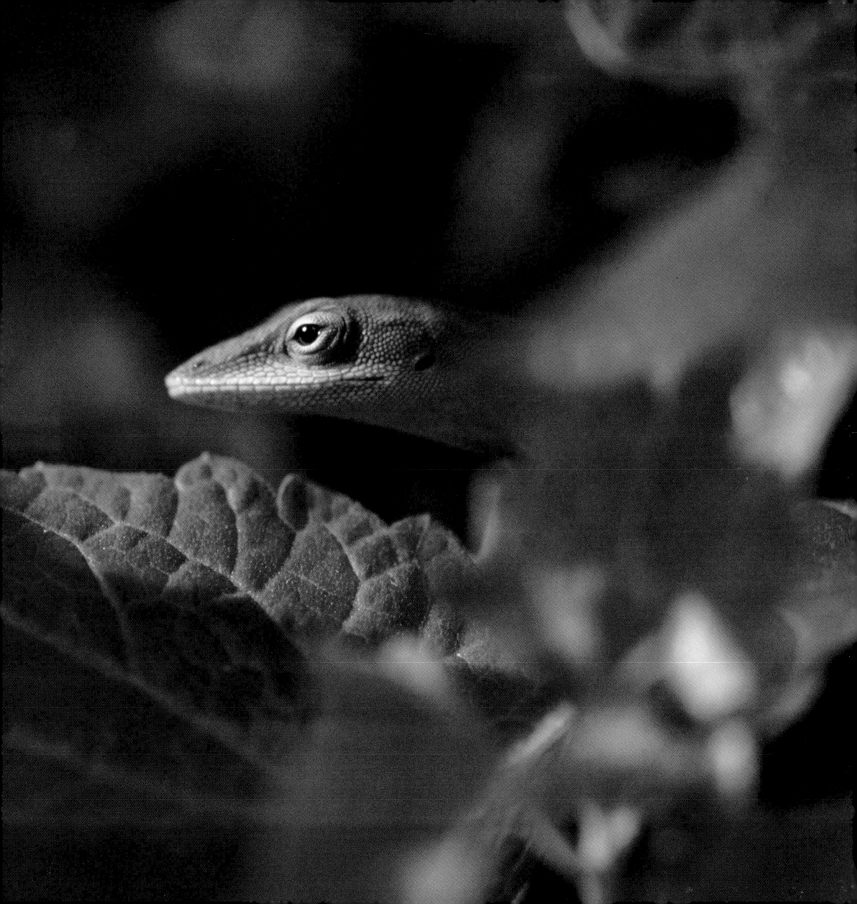

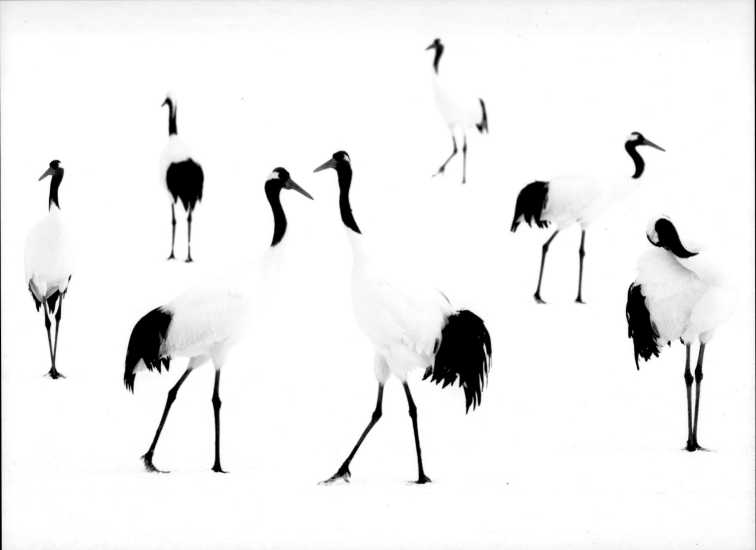

Red-crowned crane dance

JAN VERMEER

The red-crowned crane is the largest of all the cranes at well over a metre tall, and with a wingspan of more than two metres. Highly endangered, it occurs only in northeastern Asia. It is resident only in Japan, mainly on the northern island of Hokkaido. It is loved by photographers for its elegance and spectacular courtship dance. 'Their choreography on the snow field was perfect.'

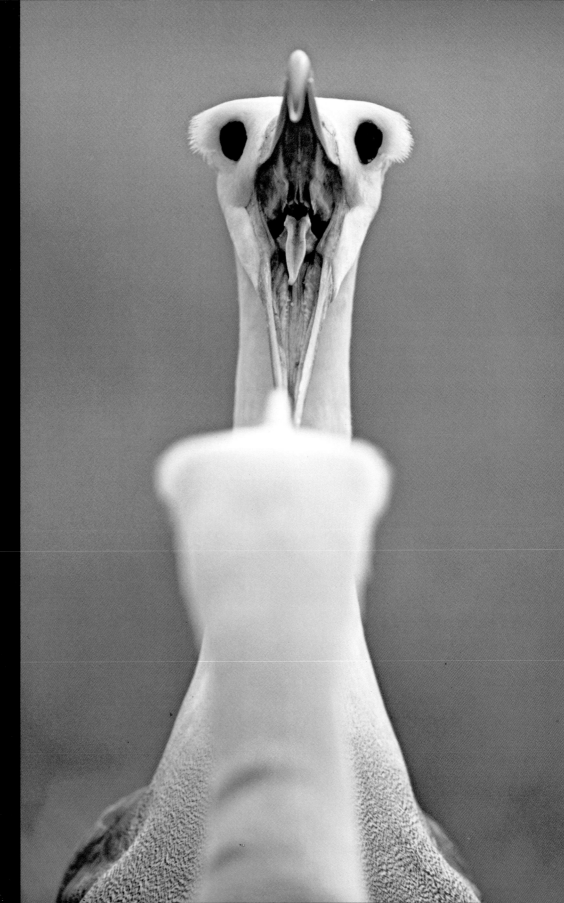

Courting Galápagos albatrosses

WINFRIED WISNIEWSKI

Galápagos albatrosses mate for life. Every year they meet up at the same place to breed, having spent most of the year alone at sea. The birds carry out intricate courtship rituals to cement their pair-bond after such a long time apart. The males and females face each other and in a synchronised display they bow, sway their head and snap their bills shut with a loud clap. They also 'fence' by rapidly flicking their bills against each other. They repeat these dances for up to an hour at a time, and sometimes many times a day.

Canon EOS-1V, with 600mm f4 lens with 1.4 extender; automatic exposure; Fujichrome Velvia; Sachtler tripod.

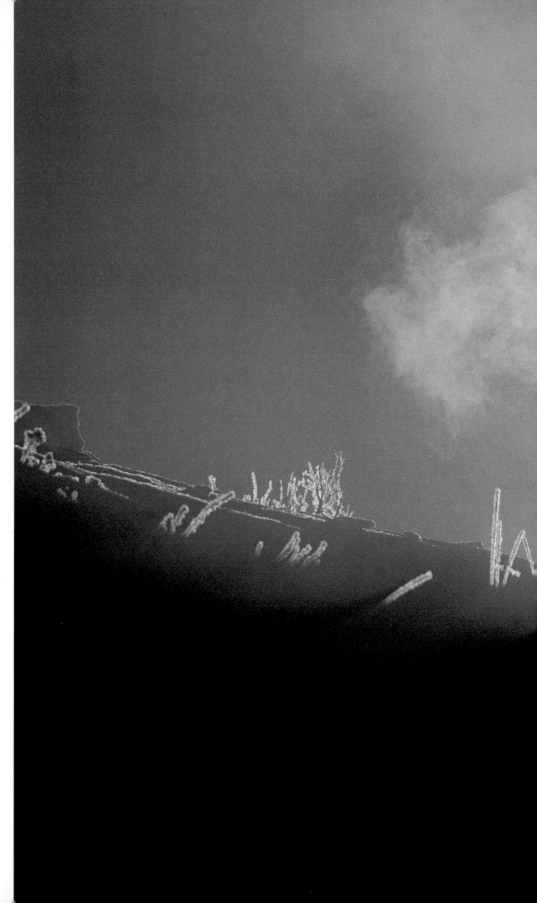

American bison defrosting

MERVIN D COLEMAN

This photograph was taken in the Lamar Valley, Yellowstone National Park, USA. 'Early one bitterly cold morning, I came across three bison standing by the side of the road. It had been –26 degrees centigrade that night, and they were still covered in frost. I noticed that the sun was just beginning to peek over the far ridge, silhouetting one of the bison. As steam began to rise from his frost-covered body, it added moisture to the air, creating a prism of colours around this classic symbol of the American West. It was a magical, almost spiritual moment.' Bison eat mainly grass. In the snow they dig by moving their head from side to side to reach the grass below.

Canon A2-EOS with Canon EF 300mm lens plus Canon 1.4 Tele-extender attached for a focal length of 420mm; Fujichrome Velvia; tripod.

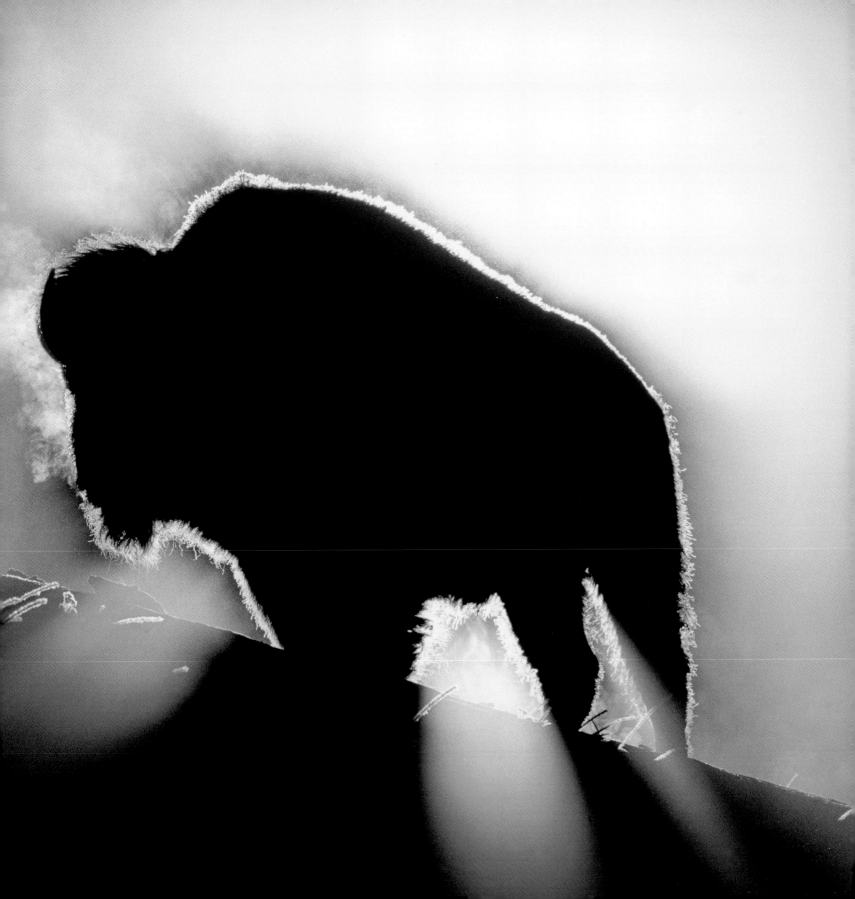

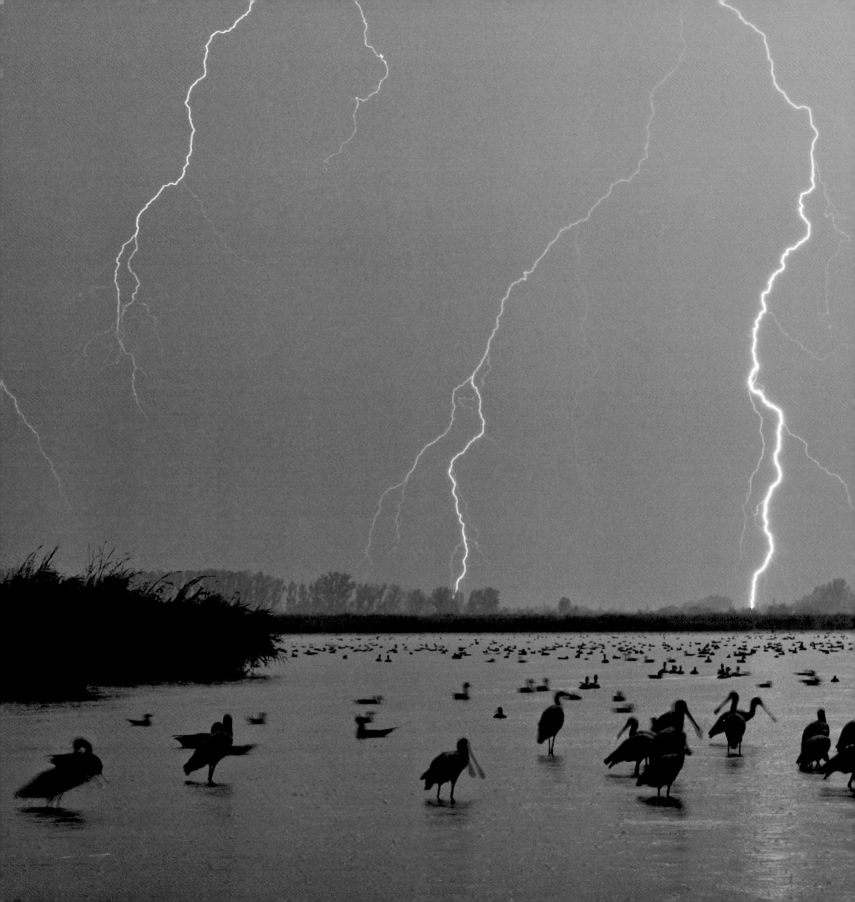

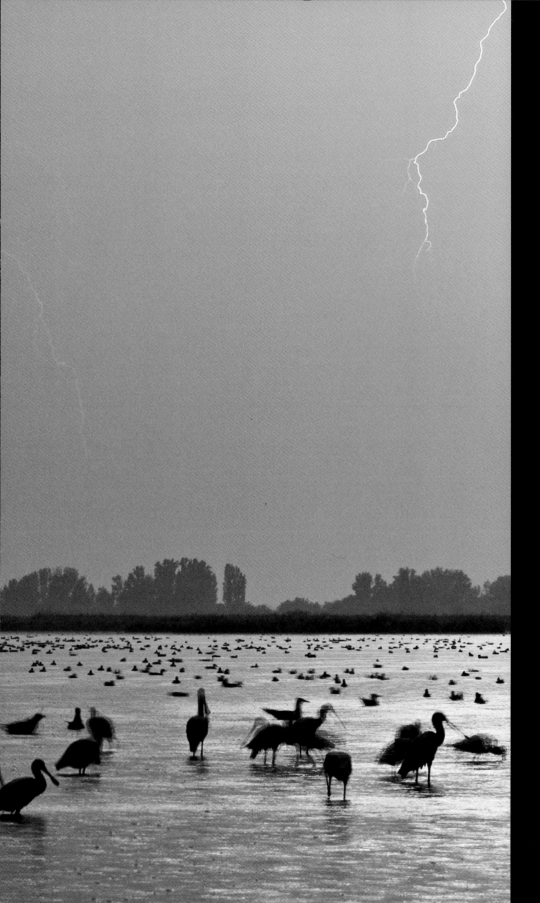

Lightning birds
BENCE MÁTÉ

Bence is continually on the lookout for storms, though usually the lightning flashes too high in the sky to be photographed. This time – on Lake Csaj, in Kiskunsag National Park, Hungary – the lightning forked right to the ground. 'My tripod was shaking from the thunder, but my mood was electric. It's so rare to get just the right mix of beautiful light, birds and lightning. The wildfowl and gulls didn't seem bothered. They continued with their evening preparations as the light faded and heavy rain fell.'

Canon EOS 300D + Canon 28–80mm f4 USM lens; 30 sec at f2.8; tripod; hide.

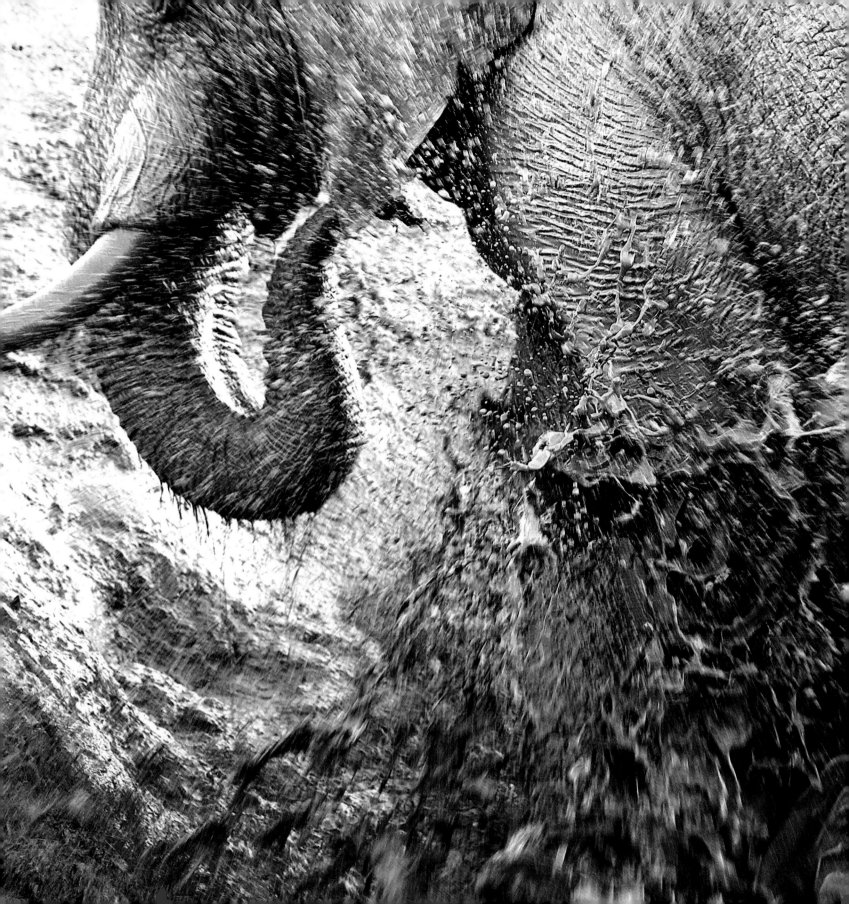

Elephant creation
BEN OSBORNE

'I staked out this waterhole in Botswana's Chobe National Park for three weeks, taking pictures from my vehicle of thirsty elephants and other animals coming to drink. Sometimes the waterhole overflowed, and this huge bull was the first to indulge in an energetic mudbath. I focused on the centre of the action, an explosion of texture and colour.'

Canon EOS 1D Mark II N + 70–200mm f2.8 lens (set at 135mm); 1/50 sec at f5; ISO 400; beanbag.

Foxgloves

OLAF BRODERS

Olaf first came across this bloom of foxgloves on a foothill of the Olympic Mountains, Washington State, USA, in the middle of the day. 'The bright sunlight made the flowers produce shadows, disturbing the pattern between the evenly distributed flowers and the tree trunks in the background.' He decided to return later at twilight in order to get the softer, evening light which lowered the contrast, and he also used a long exposure time to create a harmony of shapes and colours.

Nikon F90 with 80–200mm lens; 30 sec at f16; Fujichrome Velvia rated at 40; tripod.

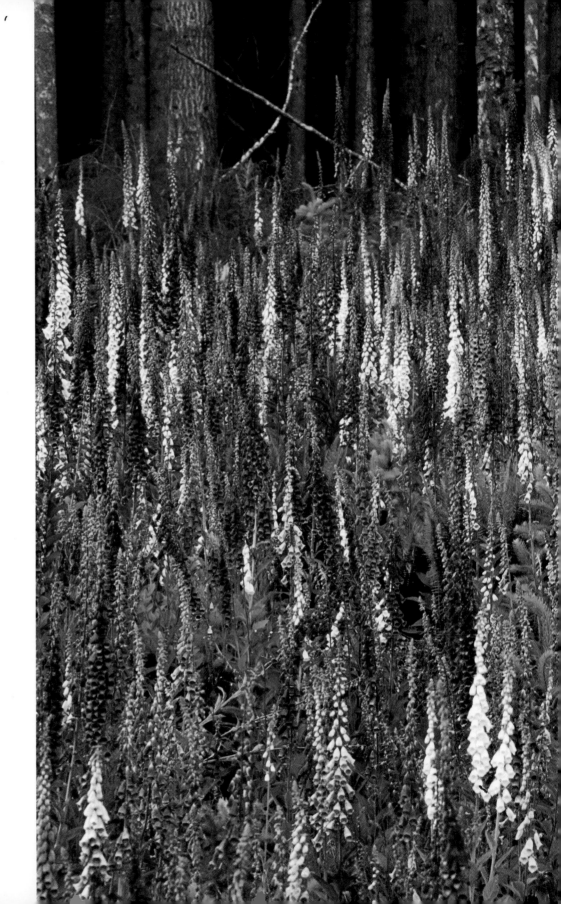

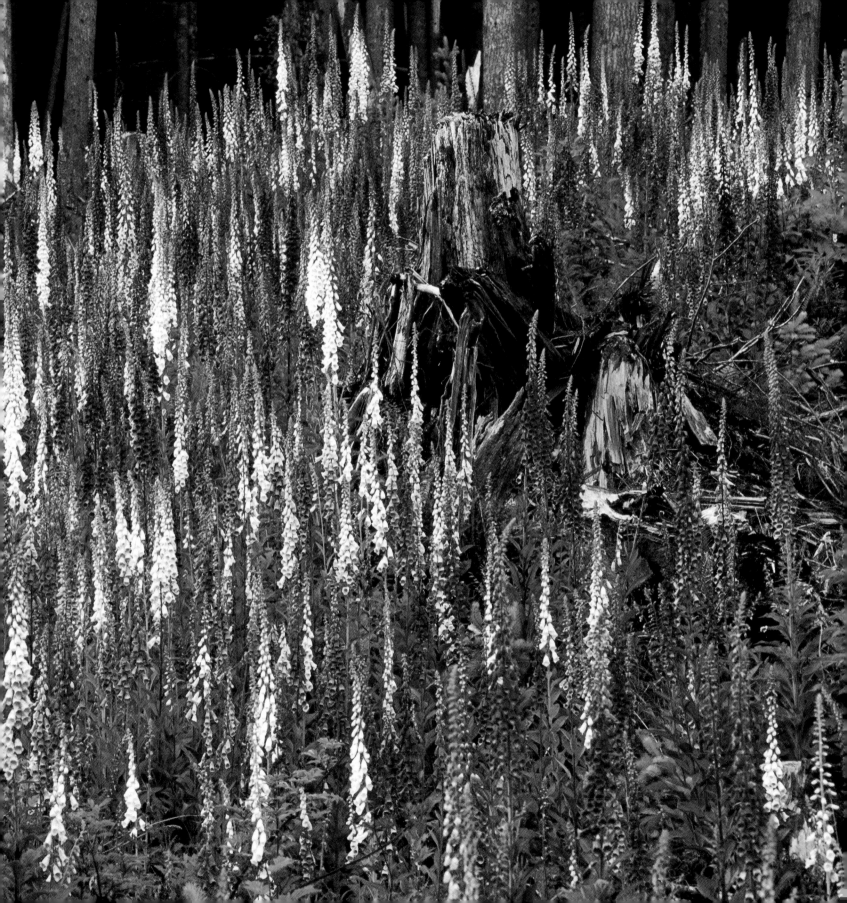

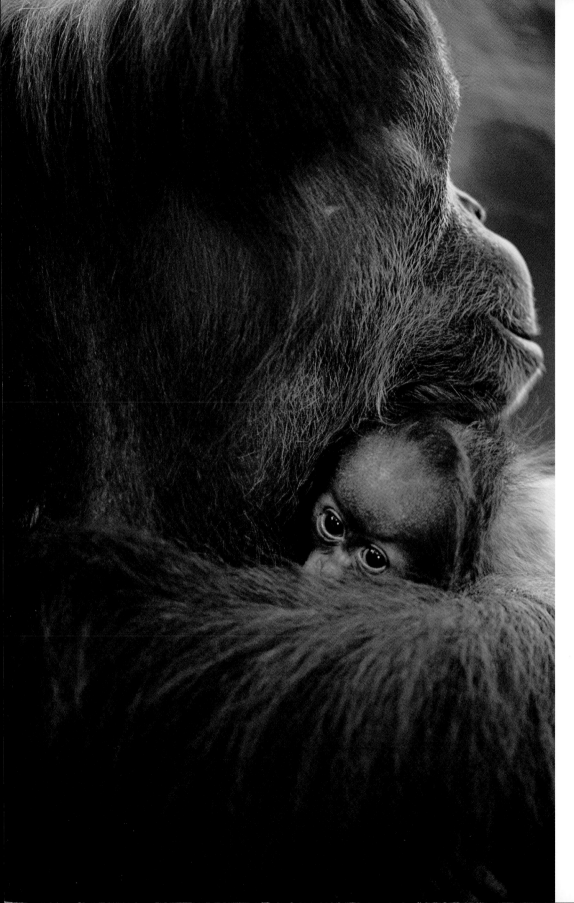

Orang-utan and baby
MANOJ SHAH

The location is Gunung Leuser National Park, Sumatra, Indonesia, this female was three when she arrived. She was released four years later and this is her third wild-born infant. 'I watched them for a long time. Eventually, the female turned her face into the light that filtered through the forest canopy, just as the baby looked up from its suckling.' Orang-utans are critically endangered because the forests where they live are under threat. Most orang-utans live outside protected areas and a dramatic increase in demand for timber after the December 2004 tsunami has put renewed pressure on their habitat.

Canon EOS 1N with 300mm lens; 1/30 sec at f4; Fujichrome Velvia; monopod.

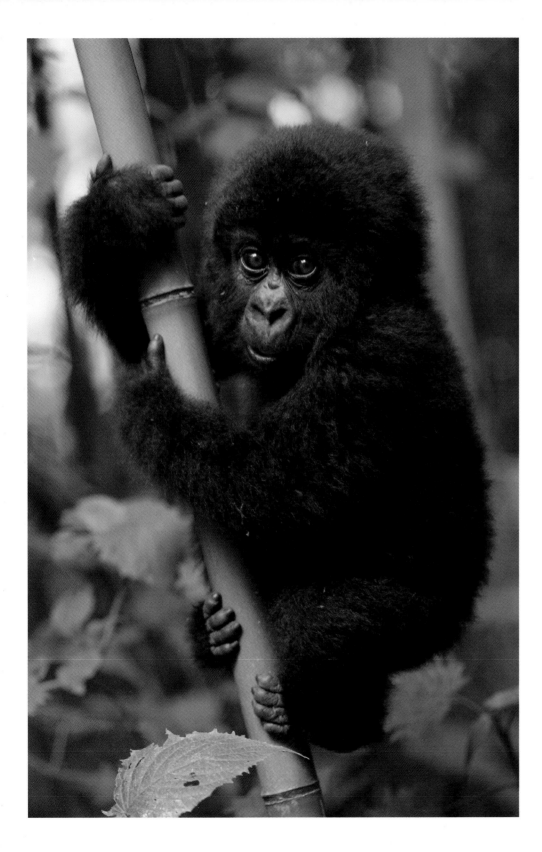

Human encounter

SUZI ESZTERHAS

While his mother collected nettles in the Volcanoes National Park, Rwanda, this 10-month-old mountain gorilla played on a bamboo stem. After climbing a few metres, he stopped to look at Suzi. 'It was like looking into the eyes of a human – an adorable moment. He seemed so vulnerable.' With just 680 mountain gorillas remaining across Rwanda, Uganda and the Democratic Republic of Congo, they are highly endangered.

Canon EOS 1D Mark II, with 70–200mm f2.8 lens; 1/200 sec at f3.2; 800 ISO.

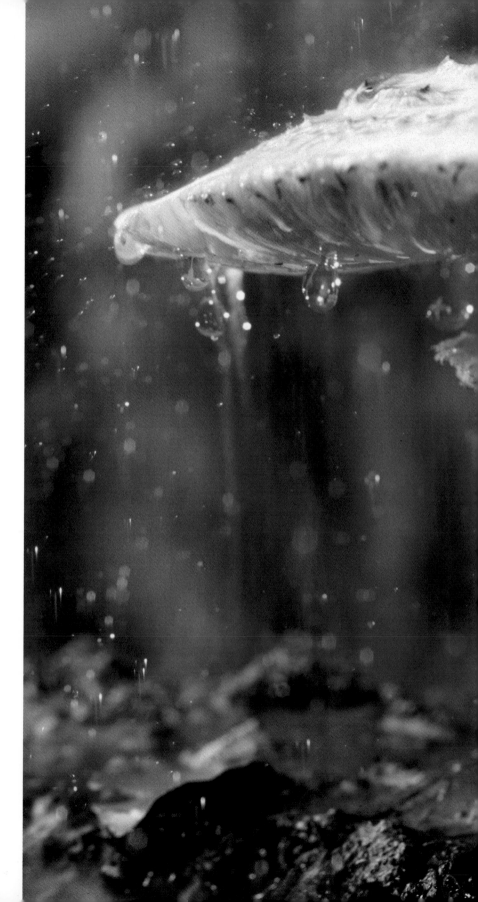

Sheltering frog

EDWIN GIESBERS

'I set off to photograph fungi in a forest near my home in Arnhem, the Netherlands, but it was raining hard. I spotted this toadstool and then noticed the frog. I approached very slowly and used a slow shutter speed to show up the rain.' With the help of a little rain, toadstools can grow very quickly, even reaching their full size overnight.

Nikon F801s with 200mm lens; 1/15 sec at f8; Fujichrome Sensia 100.

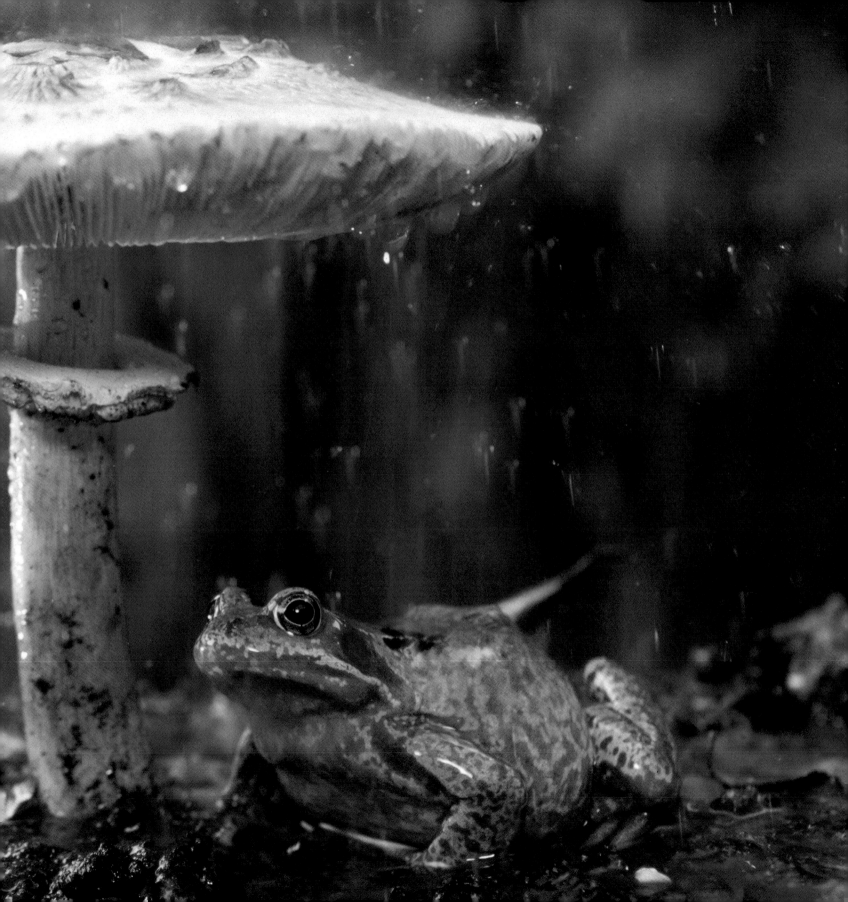

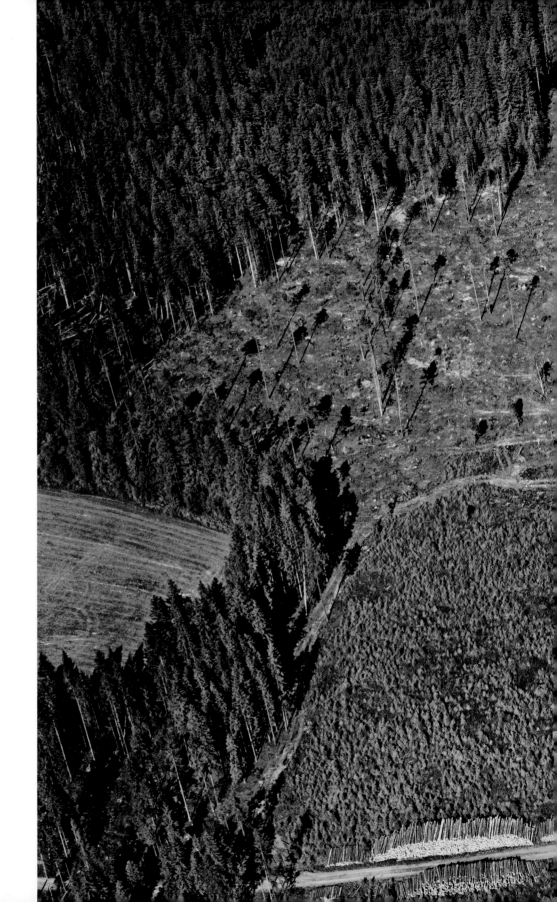

Hurricane tree

JOCKE BERGLUND

In January 2005 southern Sweden was devastated by a hurricane. Jocke specialises in aerial photography and was flying over Småland when he saw this 'remarkable oak tree print'. It had been formed by the hurricane and also the effect on the soil of logging machines collecting trees. 'It's as if the heavens had sent a message to the forest industry reminding them that, in this area, deciduous trees would have withstood the winds much better than pine.'

Canon EOS-1Ds Mark II with 28–70mm f2.8 lens; 1/800 sec; 200 ISO; Cessna aircraft.

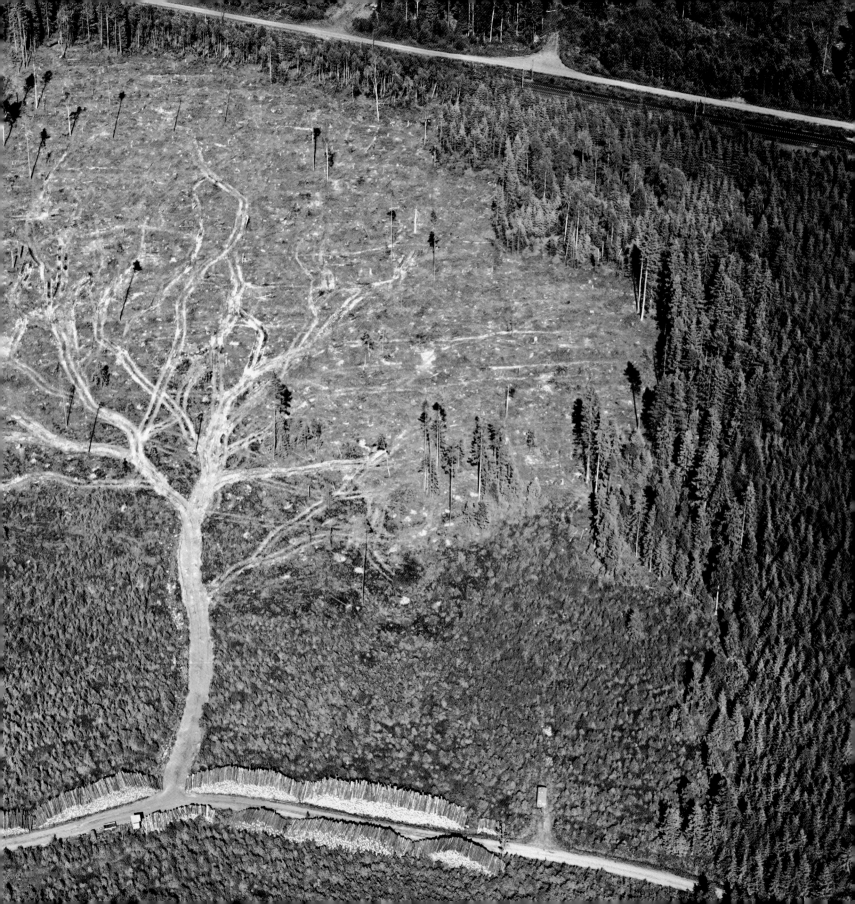

Arctic North America and north-western Greenland, and then migrate south in November and stay until March. 'For the past fifteen years, I've spent more than 400 winter days photographing snow geese and cranes there and have experienced "fire-in-the-mist" only three times. As the early morning sun burned through the ground fog, it gave the impression of a huge blaze.'

Canon EOS 1N with EF600mm lens; evaluative metering + 2/3 stops; 1/320 sec at f5.6; Fujichrome Velvia.

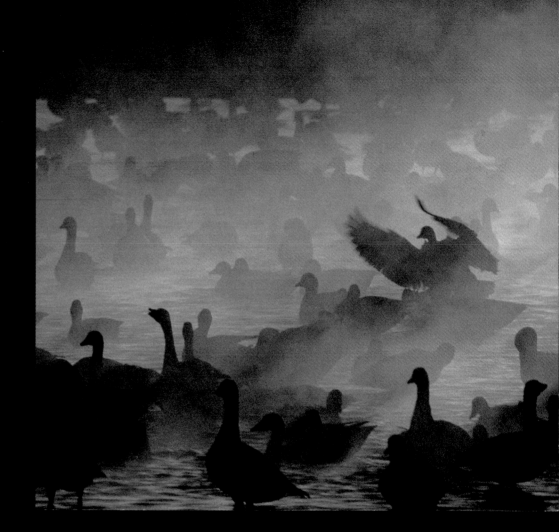

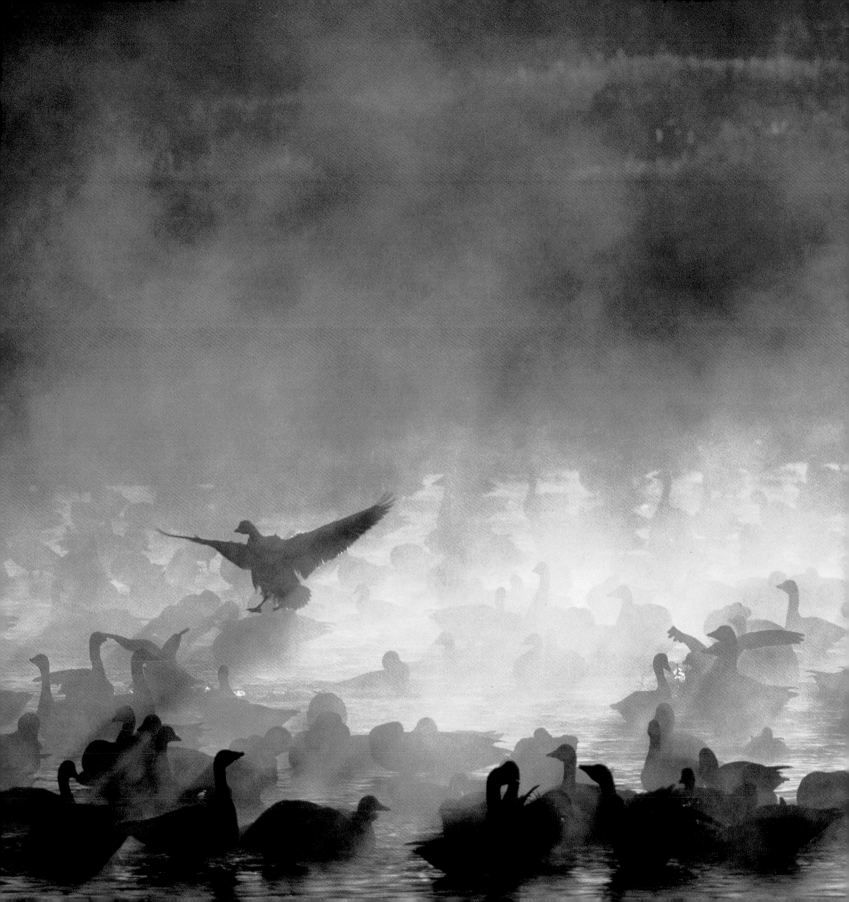

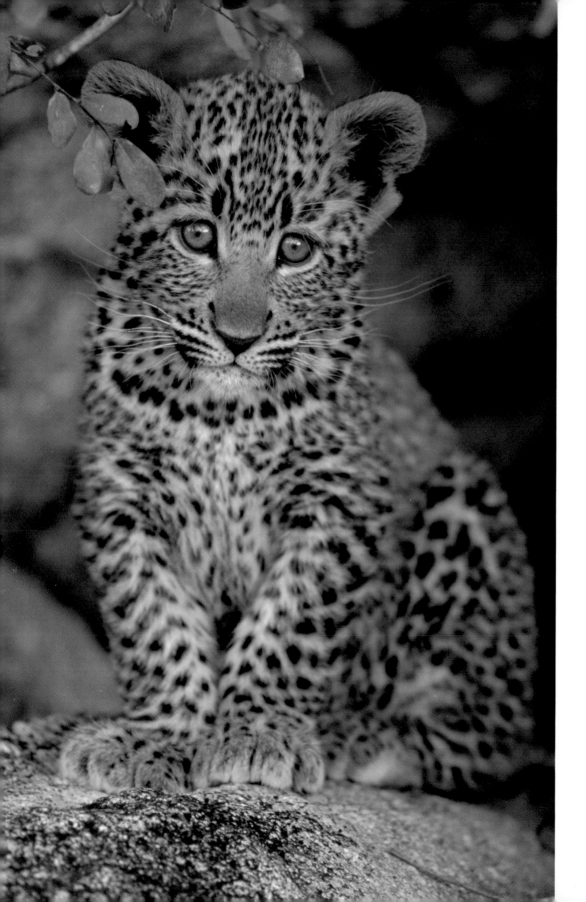

Leopard cub

PETER CHADWICK

'This cub was the only one of the litter and was very bold. I often watched it at the entrance to its lair in the Mala Mala Game Reserve, South Africa, amusing itself by chasing its tail or tumbling in the leaves.' Leopards are found nearly all over Africa, though in the north they are almost extinct as the result of habitat loss and hunting for trade.

Nikon FX90 with 300mm lens; flash; 1/60 sec at f4; Fujichrome Provia 100.

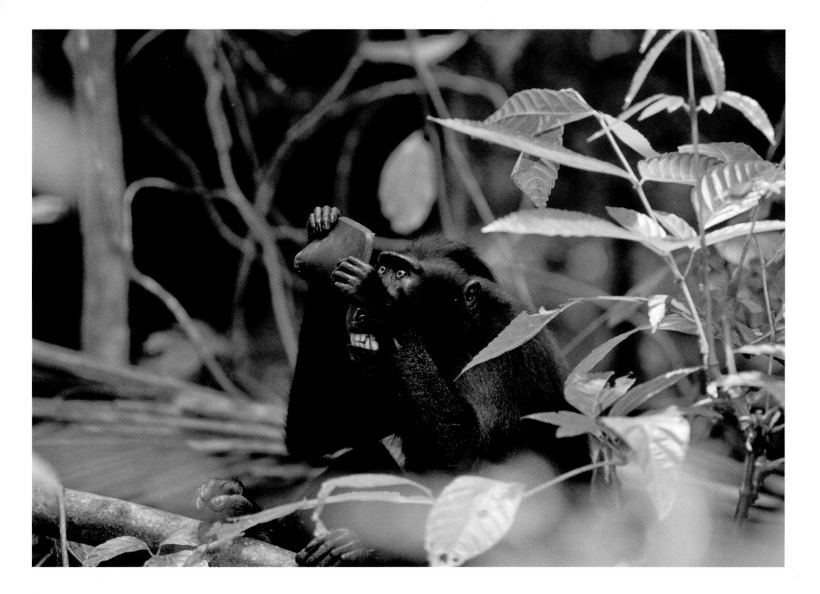

Celebes macaque reflecting

SOLVIN ZANKL

'Logging roads now slash through the rainforest, exposing animals to things they have never experienced. I spent a few weeks following a group of black apes. One day, I noticed a male fall behind the group. He'd found a car wing-mirror and was seeing his own image for the first time.' The Celebes macaque is only found on the island of Sulawesi in Indonesia. Now critically endangered, its habitat is under pressure from logging, farming and mining.

Nikon F5, with 300mm lens; 1/125 sec at f2.8; Ektachrome E100VS; tripod.

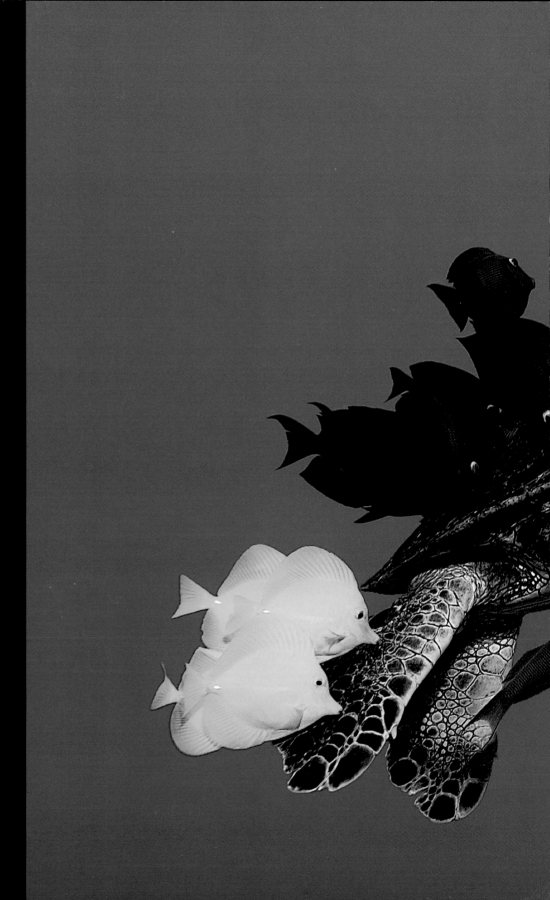

Green turtle grooming
ANDRE SEALE

These fish are nibbling algae and parasites growing on the turtle's shell and skin. 'It seems like a win-win situation for all, providing a meal for the fish and helping the turtle stay healthy and clean.' The fish in this photograph, taken in Kailua-Kona, Hawaii, are yellow tang and two species found only in Hawaii – goldring surgeonfish (the blue fish) and a saddleback wrasse (underneath). Green turtles are named for their green body fat. The green tinge probably comes from their plant diet – they especially like sea grass.

Nikon D100 with Nikkor 12–24mm lens; 1/80 sec at f8; Nexus Master housing, dual YS90DX strobes.

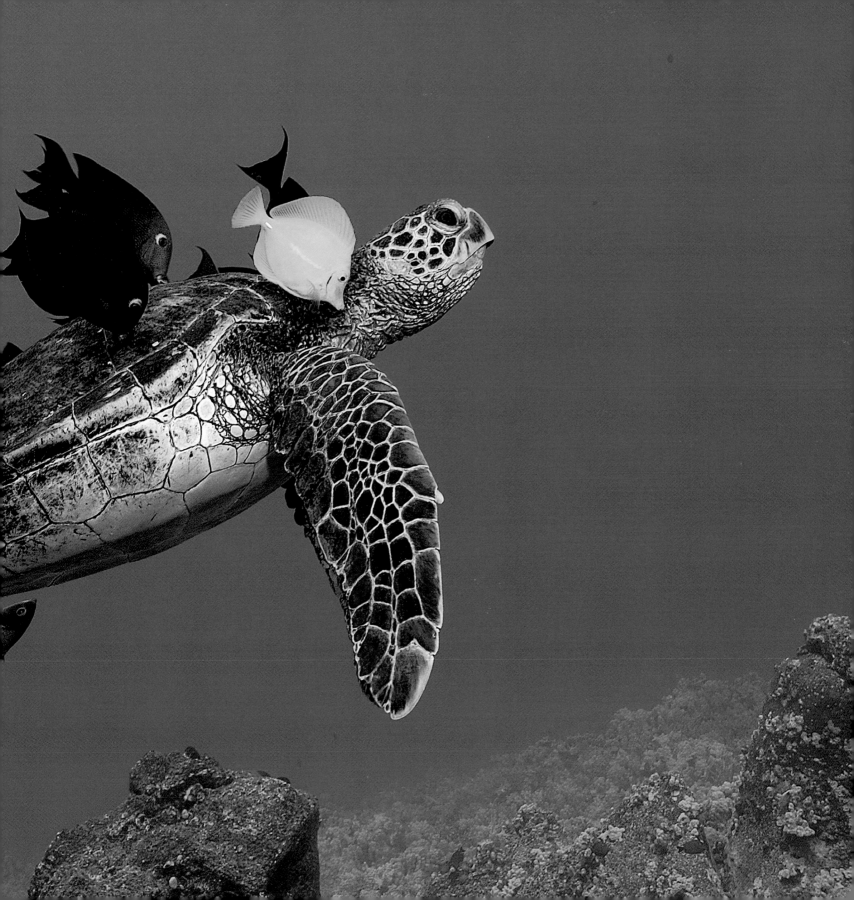

Zebra crossing

ANUP SHAH

Anup recalled the difficulties of taking this photograph: 'It was an expensive shot in some ways. It took time to set up the remote system in the Serengeti National Park, in Tanzania, and money to service my muddy camera afterwards. But it was cheap in terms of satisfaction. I wanted to create this ant's-eye view of a large, powerful animal and a sense of its flighty nature.' Plains zebra live on the grasslands and dry savannahs of East Africa. They live in herds of usually one male and several females. Zebras are skittish animals and if one senses danger the whole herd charges away.

Canon EOS 1V with 20mm lens; Fujichrome Velvia 100F.

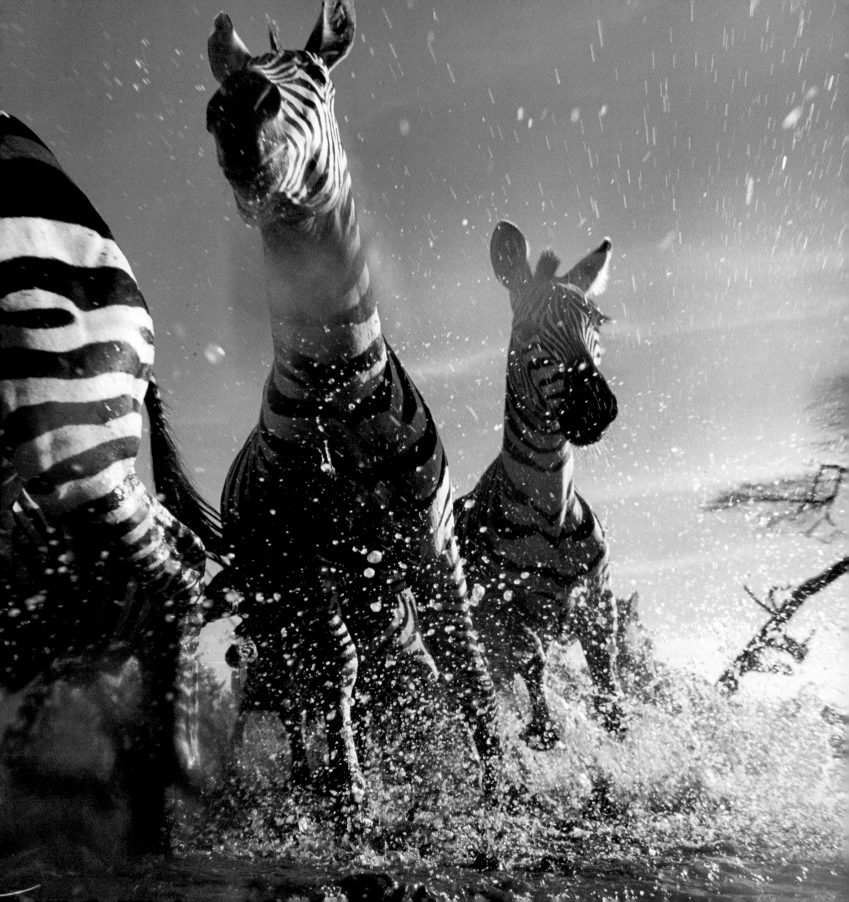

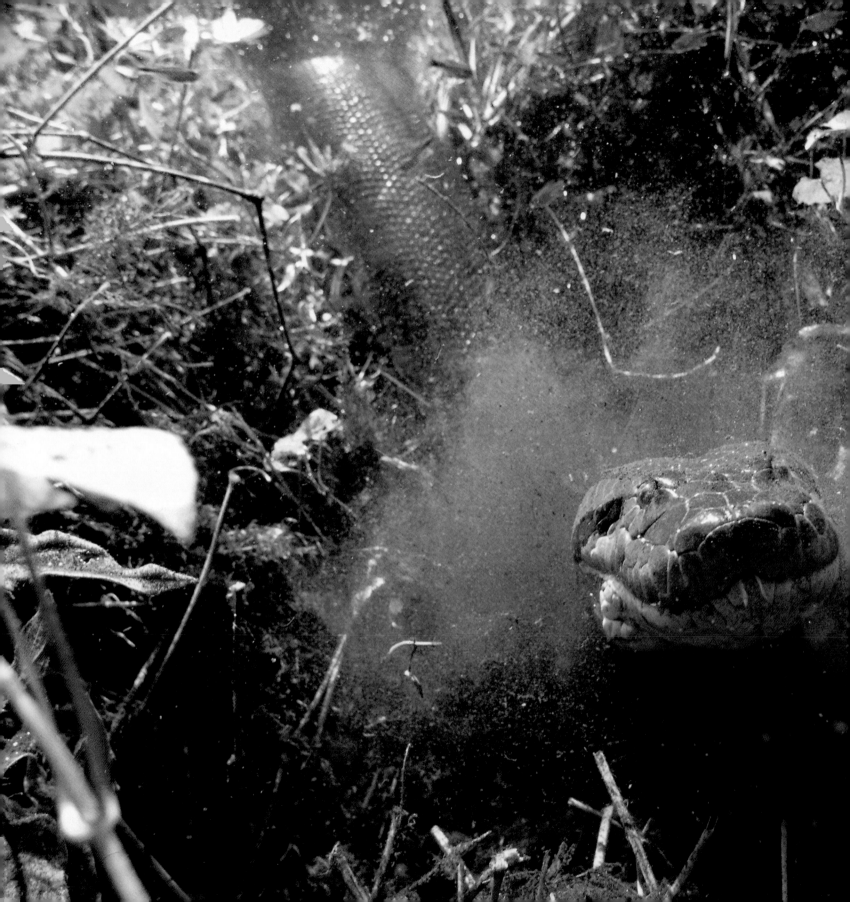

Anaconda underwater

MICHEL LOUP

Michel saw this six-metre-long female anaconda on the bank of a river in Brazil and slipped into the water to meet her. 'She slid down preparing to hide in the vegetation but then curiosity got the better of her and she came right up to me, looking directly at my lens for a full 10 seconds from about 20 centimetres away. I only use natural light for my underwater photography and so I was very lucky the water in this area is so clear.'

Nikonos V with 15mm f2.8 lens; 1/125 sec at f11; FujichromeProvia 400F.

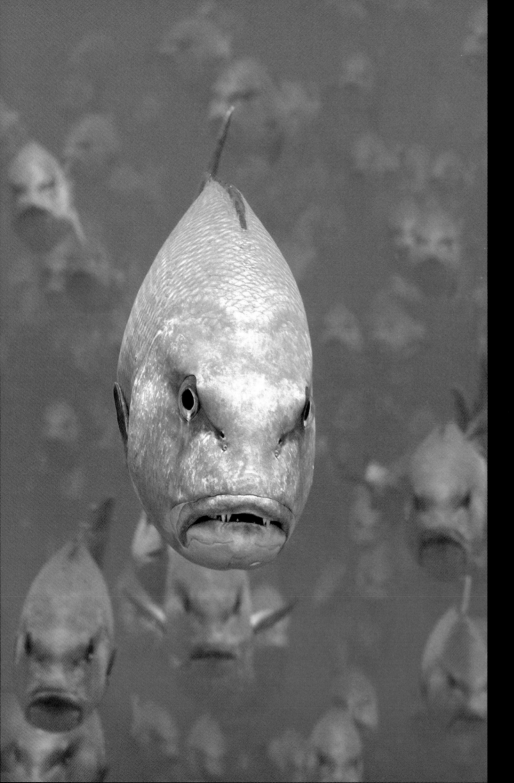

Snapper shoal
ALEXANDER MUSTARD

Snappers normally swim alone, but gather together in huge groups during the spawning season. The Bohar snapper is one of the larger reef predators in the Red Sea. Alexander travelled to Ras Mohamed National Park at the tip of the Sinai Peninsula, Egypt, specifically to photograph snappers. He wanted to highlight the fish's strange face while giving an impression of the huge and menacing size of the gathering. But outside the safety of the national park the snapper are in danger. Fishermen target whole shoals before they have had a chance to spawn.

Nikon D100 with Nikon 105mm f2.8 lens; 1/45 sec at f13; 200 ISO; Subal underwater housing and Subtronic flashes.

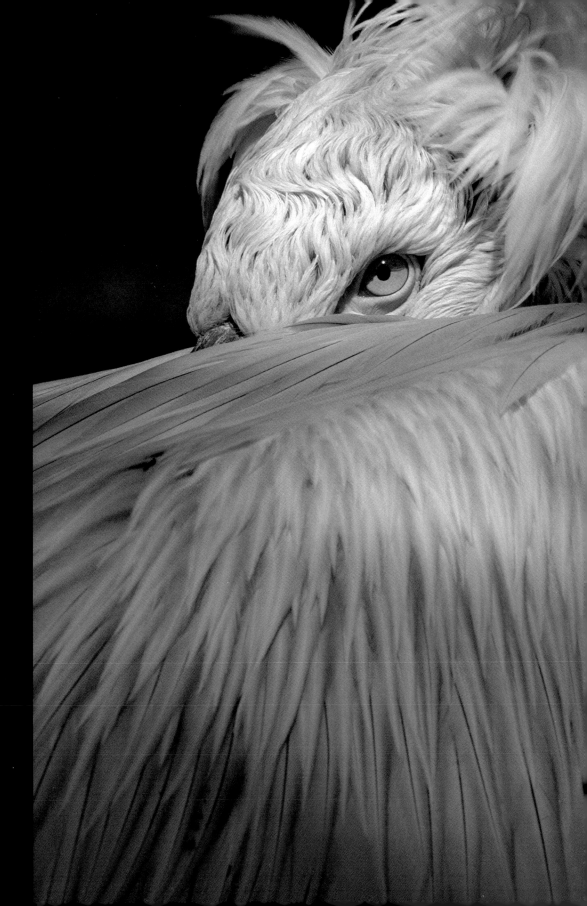

Dalmatian pelican waking up

HELMUT MOIK

Each spring, Dalmatian pelicans migrate from Africa and Asia to Europe. They make their way to the Danube Delta in Romania to breed. The birds nest on islands in the delta, trying to avoid the mainland where there are predators like wild boar. 'I arrived at the delta before sunrise, armed with a permit to enter the reserve and a guide with a boat. My guide left me at a small island where a large colony of pelicans was sleeping. At first light, this pelican opened its eyes and gave me a penetrating stare. A few seconds later, it waddled into the water to wash and begin its day.'

Nikon F5 with AFS 300mm f2.8 lens and x 2 teleconverter OE; 1/30 sec at f5.6; Fujichrome Sensia 100; tripod.

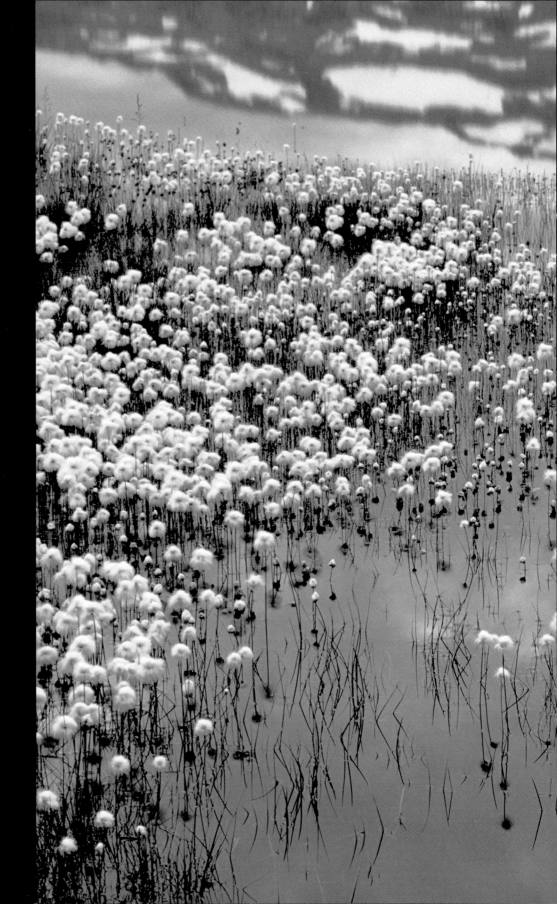

Cotton grass

JAN TÖVE JOHANSSON

For Jan, photography is as much about what you exclude as what you include. 'The mountains at this spot in Jotunheimen, Norway, were reflected in the water where the cotton grass was growing. Instead of trying to show the whole scene, I concentrated on the plants and the reflections.' The Jotunheimen National Park is home to waterfalls, rivers, lakes, glaciers and Norway's highest mountain, Galdhøpiggen. There is lots of water, which is perfect for cotton grass, and the rocks are calciferous so the area has a rich and beautiful mountain flora.

Pentax 645N with 200mm lens; 1/25 sec at f32; Fujichrome Velvia.

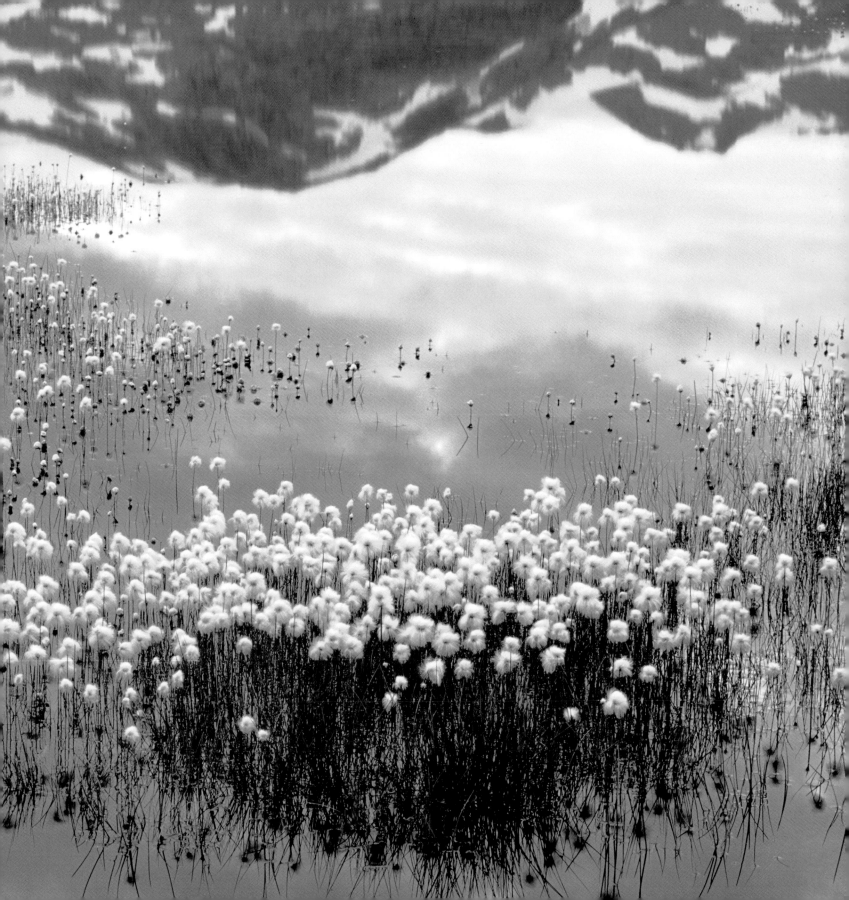

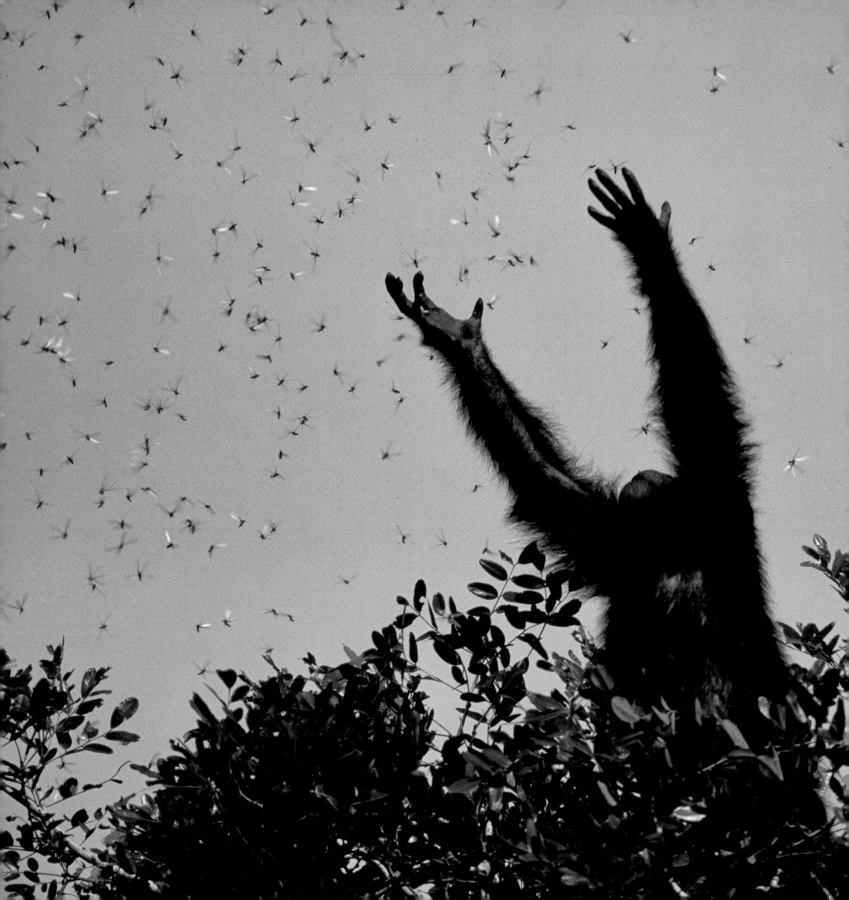

Chimpanzee's termite dinner
KRISTIN J MOSHER

Glitter, a five-year-old chimpanzee, was foraging in Gombe National Park in Tanzania. Along with her twin Goldi, she climbed a tree and started grabbing at the winged termites that were swarming all around. 'Usually the chimps stand on the ground and catch them as they crawl out of mounds,' says Kristin, 'so when the twins started to grab recklessly at the cloud of flying termites, I knew it was special. To me, the image is powerfully symbolic. It reflects the condition of the whole species – teetering on the edge of extinction.'

Canon EOS-1N with 100–400mm f4.5–5.6 IS Ultrasonic zoom lens; 1/100 sec at f6.3; Fujichrome Provia 100F.

Military macaws on the wing
CLAUDIO CONTRERAS KOOB

The use of a slow shutter-speed helps to communicate a sense of speed in this photograph, taken in Mixteca Oaxaqueña Province, Mexico. 'A major highlight of my time working on a project to promote awareness and support for the Tehuacán-Cuicatlán Biosphere Reserve in Mexico was when a military macaw colony was discovered. Sitting at the edge of the canyon they inhabited, I could enjoy the sight of at least 15 different pairs flying between the canyon walls.'

Minolta 9 with 300mm lens and 2 x teleconverter; 1/20 sec at f27; Kodak Ektachrome 100VS; tripod.

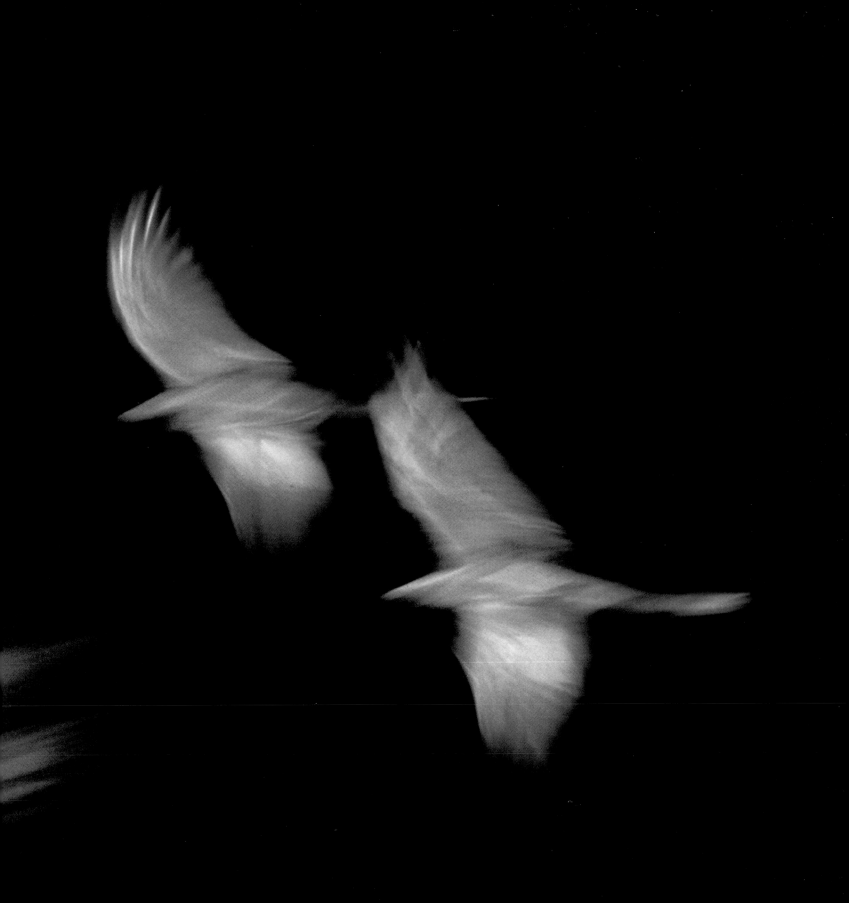

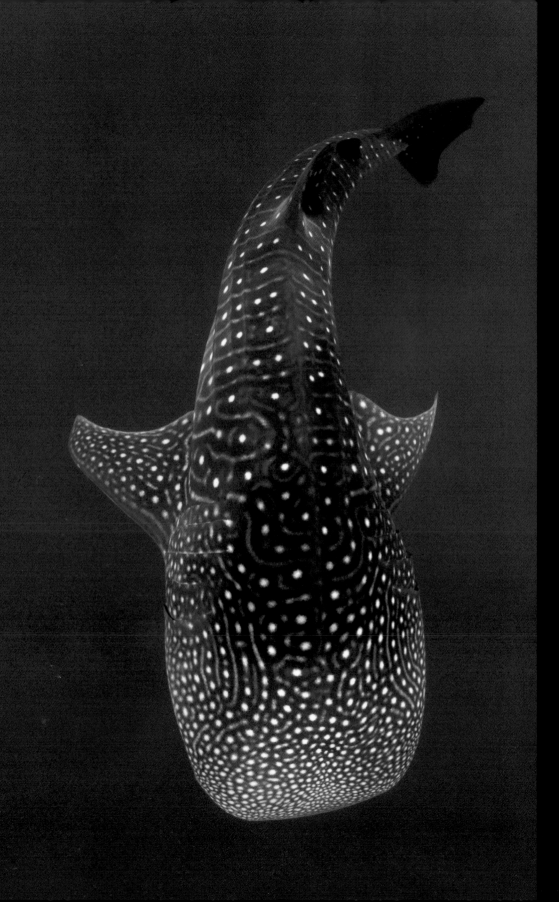

Whale shark

JÜRGEN FREUND

'After the annual mass spawning of 120 million land crabs at Christmas Island in t Indian Ocean, whale sharks gather to fee on a banquet of larvae. At other places in the world, people often have to search fo whale sharks, but at Christmas Island the sharks found us. In two months we had more than 20 shark encounters.' The wha shark is the biggest shark – actually the biggest fish – in the sea. It can grow up to 12 metres long, about the same length as a bus.

Nikon F4 with 16mm fisheye lens in underwater housing; strobe; 1/60 sec at f Fujichrome Sensia 100.

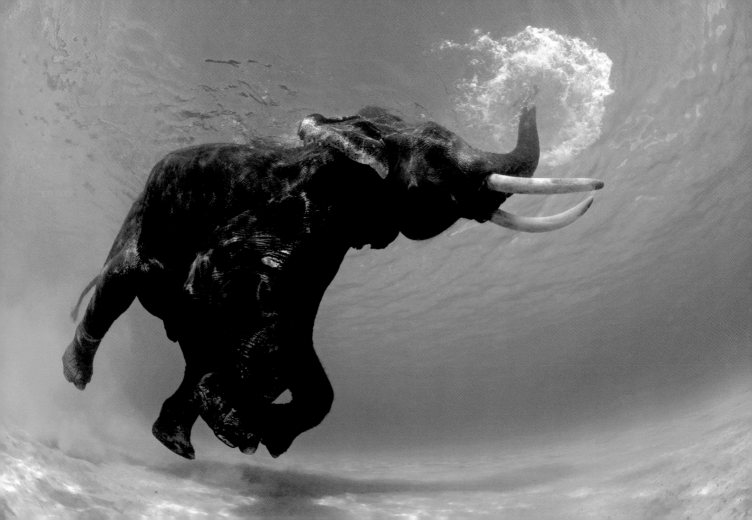

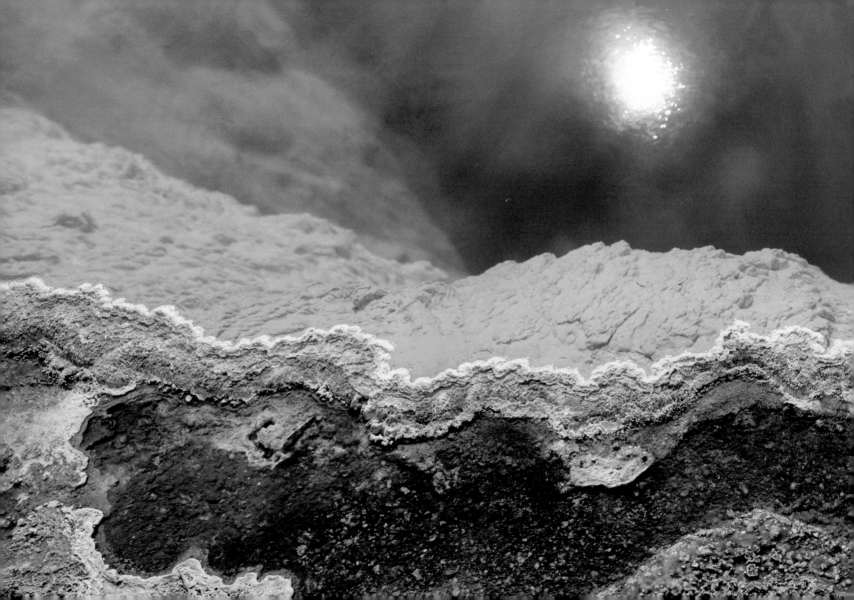

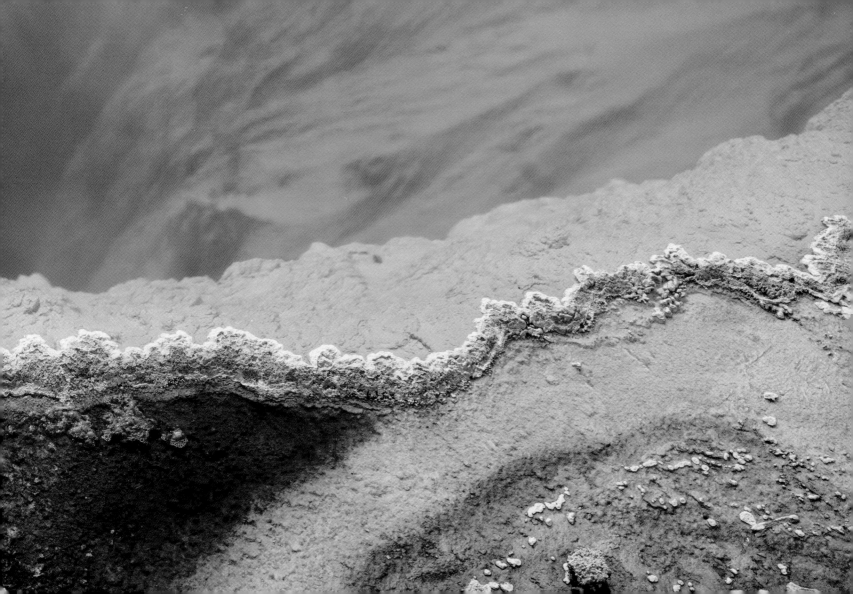

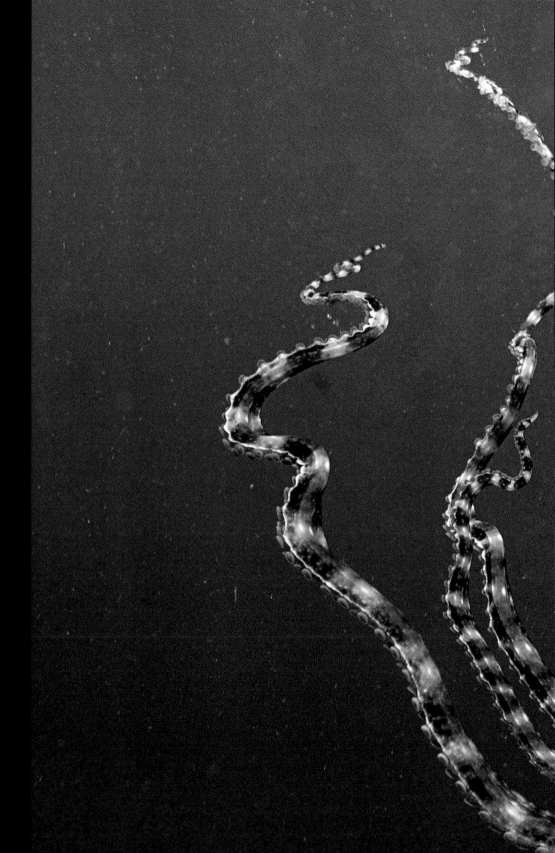

The great mimic
MICHAEL AW

Michael first thought it was a strange eel
when he spotted this Indo-Malayan mimic
octopus moving along a sandy slope near
Banka Island, Indonesia. He swam with it
for an hour, watching as it assumed the
movement and shape of a sole, ray and
even a sea snake. This master of disguises is
photographed here with its 'normal' brown
and white coat.

*Nikon D2X with 12–24mm lens; 1/100 sec at
f14; 160 ISO; Seacam housing, single S200
Ikelite strobe.*

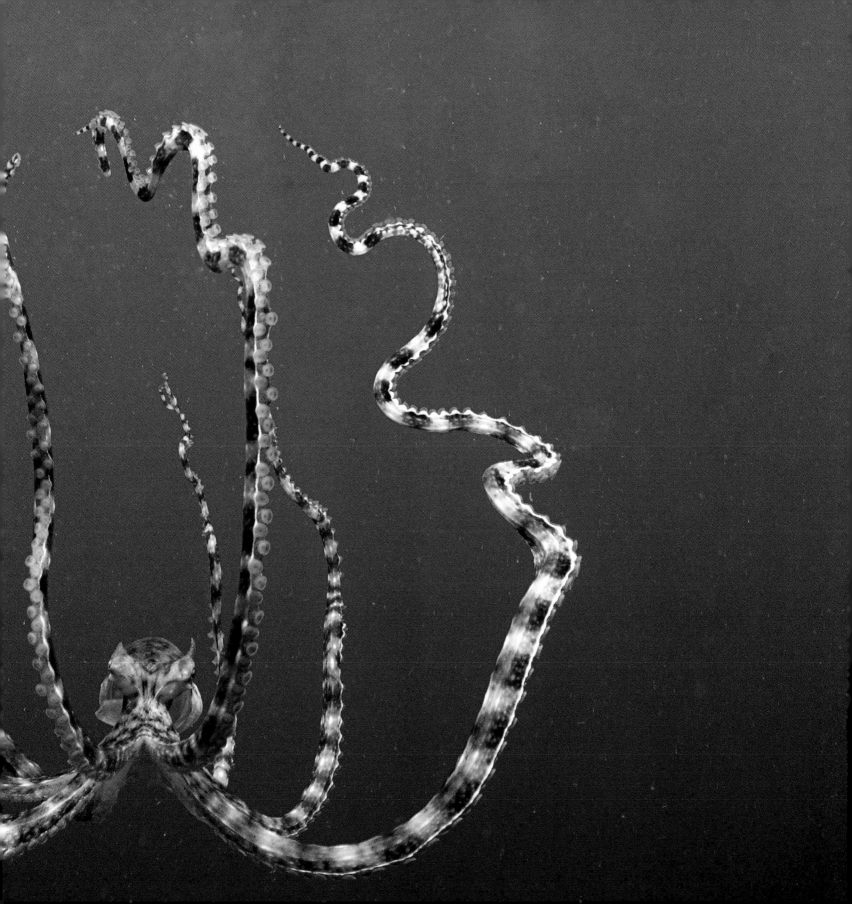

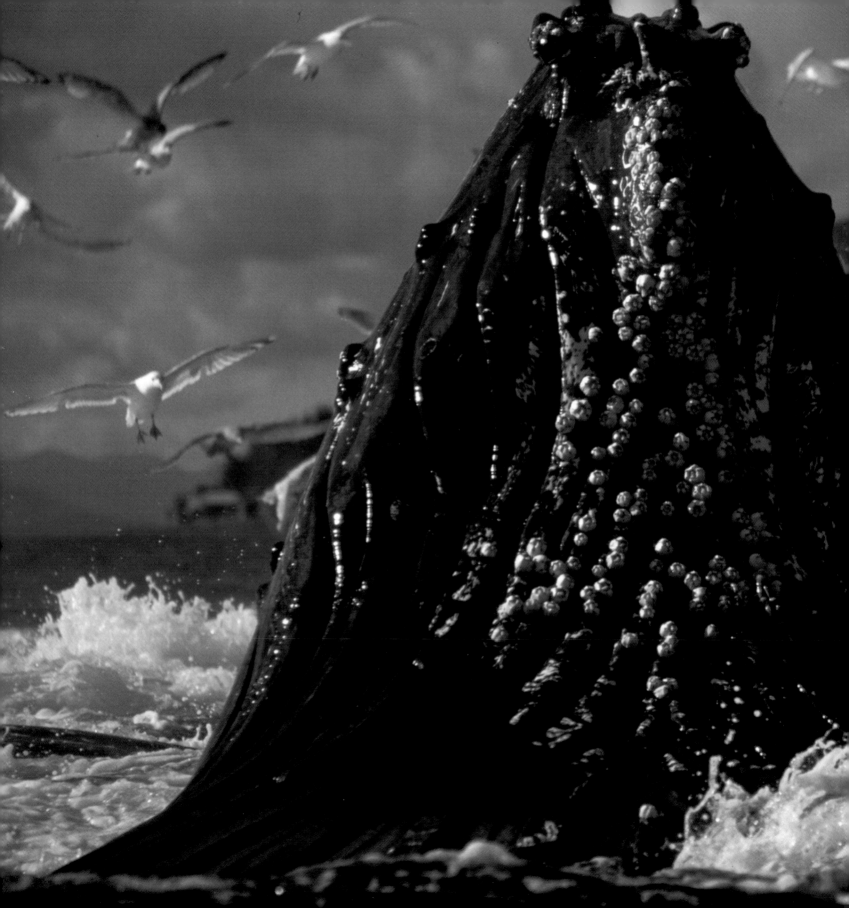

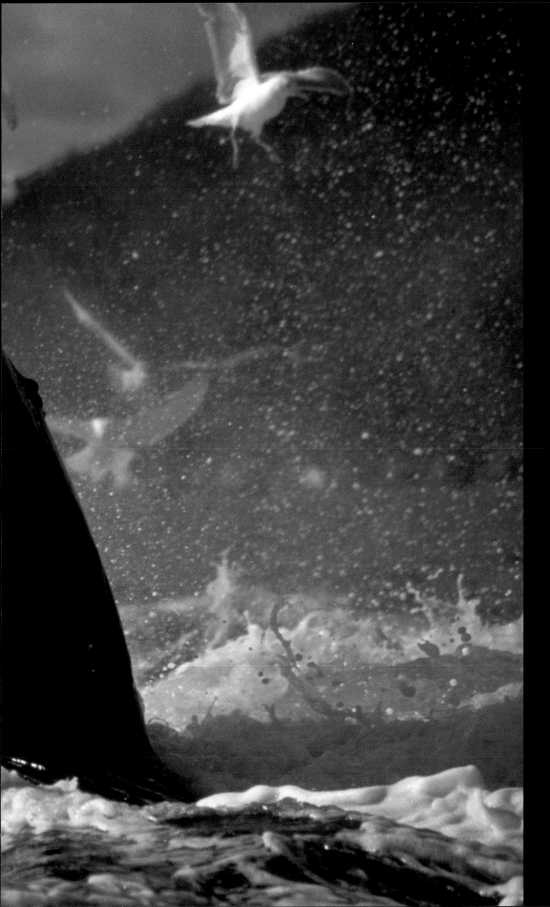

Humpback whale lunge-feeding
DUNCAN MURRELL

Duncan has spent years photographing humpback whales from a kayak off Southeast Alaska and finds the experience exhilarating. 'This is an adrenalin-charged affair as I have only seconds to exchange paddle for camera or take evasive action if I am caught in the middle of the net. This particular individual burst into view much closer than the rest of the feeding group, and I barely had time to spin around and adjust my zoom lens before it disappeared.' Humpback whales have a co-operative feeding technique called bubblenetting. They spiral round beneath a shoal of fish or krill while one whale blows air from its blowhole to form a cylindrical net, up to 45 metres across. Then, mouths wide, they swim up through the shoal scooping up prey.

Canon EOS 1N with 75–300mm lens; 1/1000 sec at f5.6; Fujichrome Provia 100.

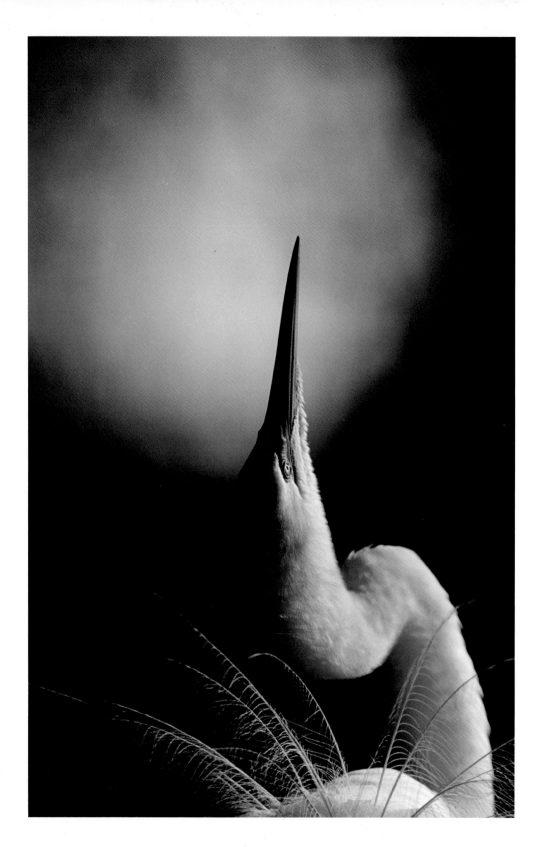

Great egret displaying
DAVID MACRI

Male great egrets work hard in the breeding season. They arrive first at the breeding colony and choose a good area for a nest. Then, to attract a mate, the males perform an intricate dance. Surrounded by females, this male in Florida began his dance in a bowed, crouched position, then, in one graceful movement, he extended his neck forward and upward. In that position, he remained motionless, eyes to the sky, his beautiful plumes displayed for the females.

Nikon F5 with Nikon 600mm f4 AF-S lens; 1/800 sec at f4; Kodak Ektachrome E100VS; Kirk Cobra head.

Beech in the mist

LUCA FANTONI AND DANILO PORTA

One foggy, grey November day in Monte Barro, Italy, Luca and Danilo found this ancient beech tree 'resembling a wise old patriarch who had gathered his subjects around in order to let them know something important.' In this atmospheric setting, the branches and twigs reaching to the sky seem like roots, gaining nourishment from above.

Nikon F90x with Nikkor 20mm lens; 1/60 sec at f8; Ilford FP4.

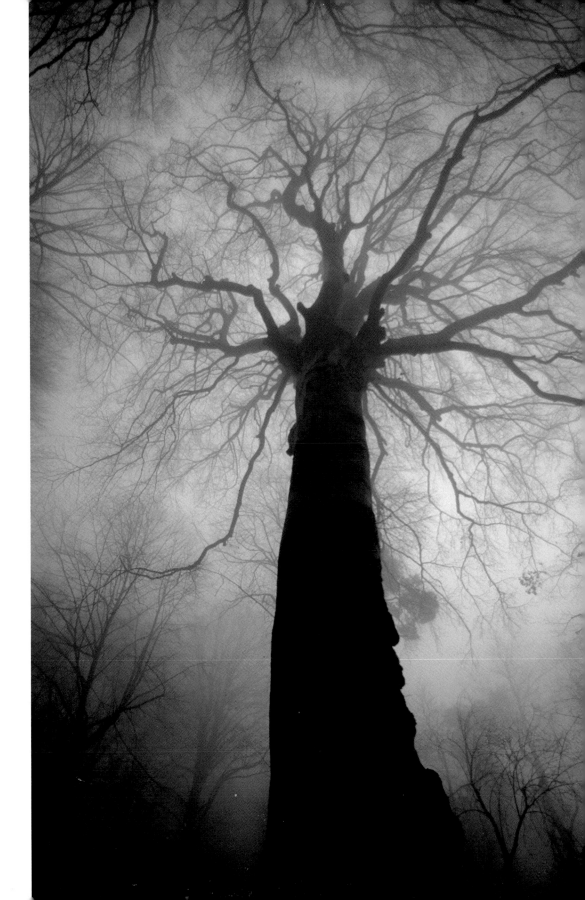

Flight of the fishing bat

CHRISTIAN ZIEGLER

'This picture was taken in the rainforest on Barro Colorado Island, Panama. The multiple images were created by a fast series of flashes. In one frame you see the swoop, the descent of the clawed hind limbs, the catch and the transfer from feet to mouth.' Bats are the only mammals capable of true flight and are most famous for navigating in the dark. The fishing bat species detects fish by echolocation. It rakes its feet through the water to impale prey, then chews in flight. It stores its catch in expandable cheek pouches so it can continue hunting.

Canon EOS 5D + 16–35mm lens at 26mm; 10 sec at f6.4; ISO 800; stroboscope flash; floodlights on boats; tripod attached to a post.

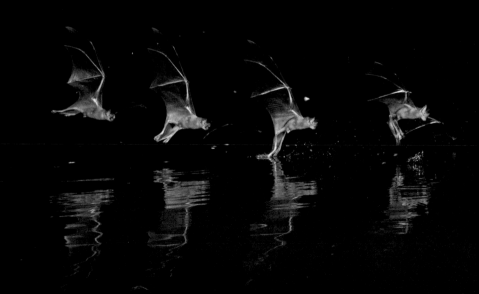

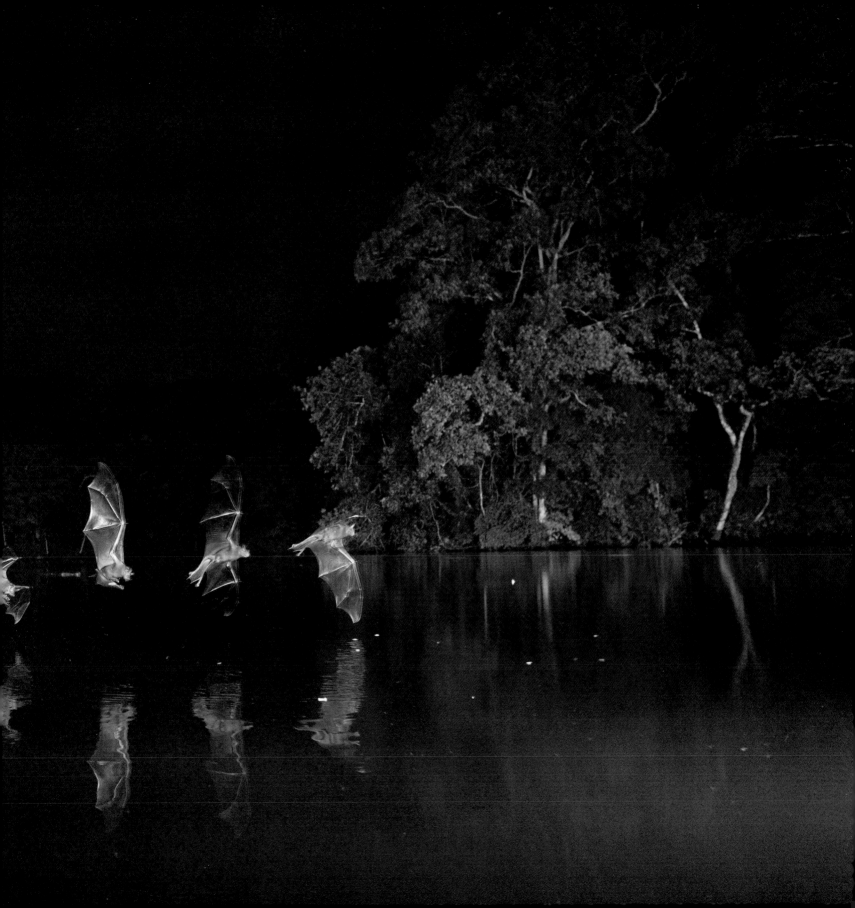

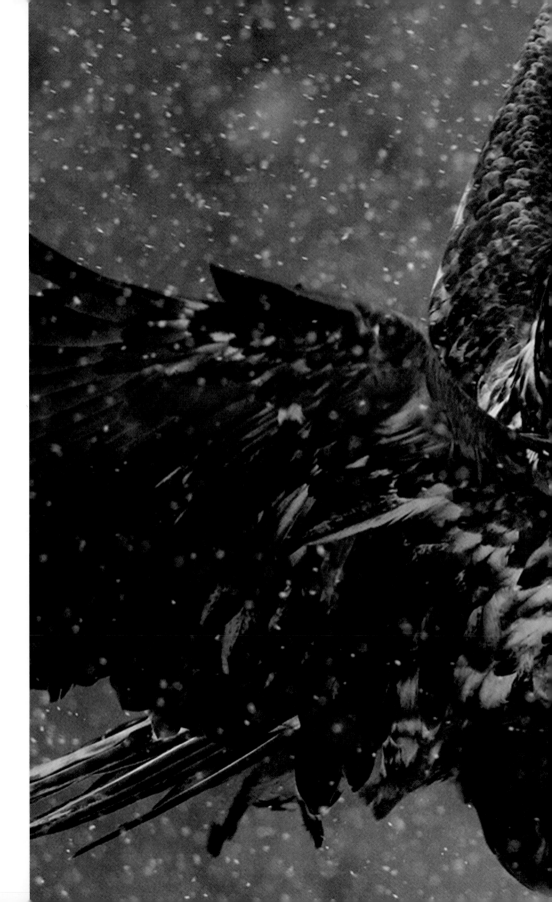

Clash of eagles

ANTONI KASPRZAK

'Photographing in Poland, I found a dead moose that would be ideal bait. Five hours later, an adult and an immature white-tailed eagle arrived together and a struggle broke out. The older, more experienced bird won, forcing the immature eagle to wait its turn for more than an hour, along with other scavengers.' White-tailed eagles are the largest eagles in northern Europe, with a wingspan of more than two metres. Mature birds have a yellow beak, while the juveniles' beaks are a darker brown. Eagles will swoop and catch fish, but will also feed on carrion. When winter is particularly cold, and food is scarce, fights over food break out.

Canon EOS 40D + Canon EF500mm f4 IS USM lens; 1/1000 sec at f4.5; ISO 500; tripod.

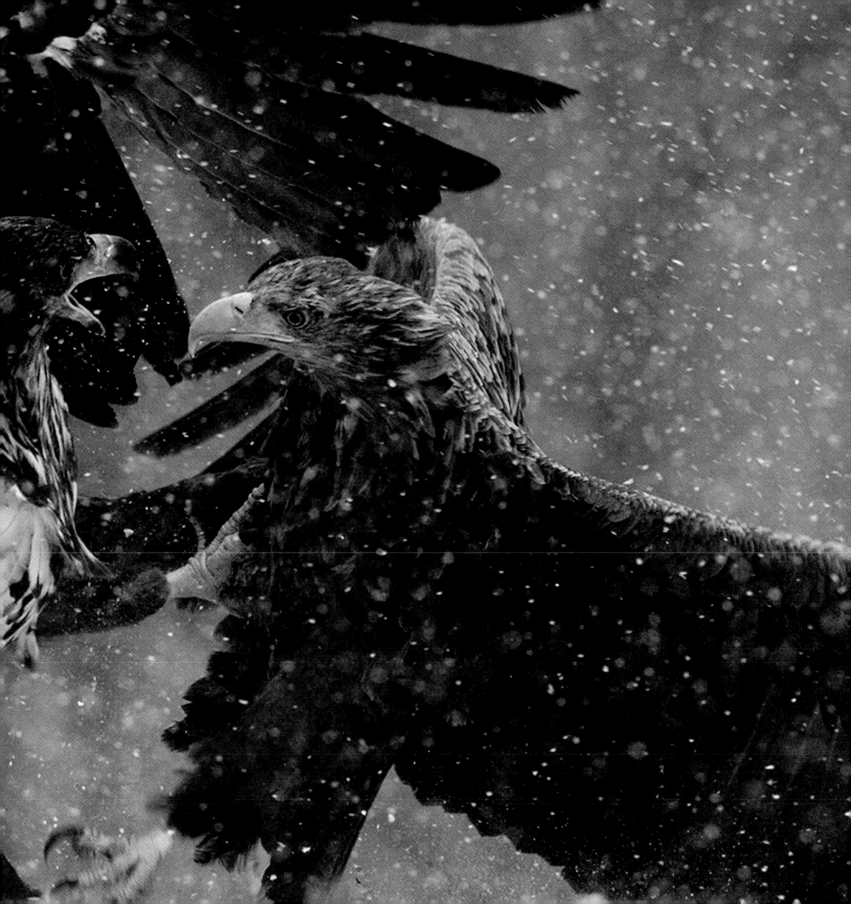

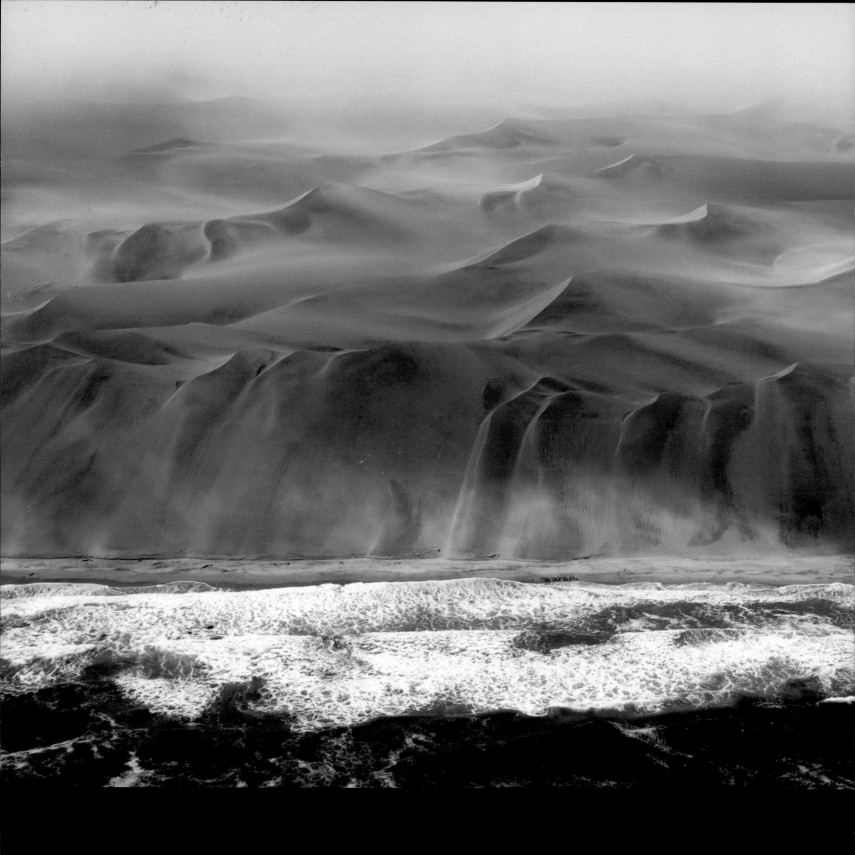

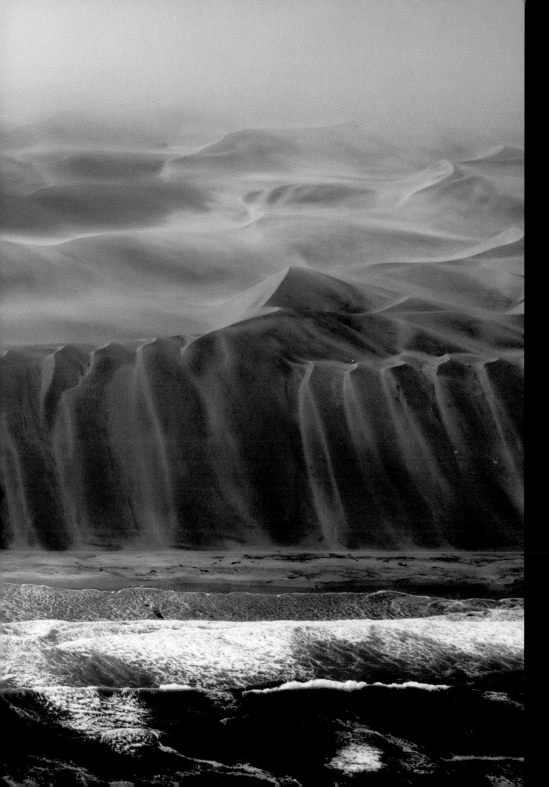

Skeleton Coast

ANDY BIGGS

'As I peered through the scratched airplane window, I wondered how I could convey the giddy heights of the Namibian sand-dunes. I wanted to capture the way shafts of sun pierce the mist and highlight the sand textures. The huddle of Cape fur seals – a dark smudge on the strip of beach – gave a sense of the vastness of this wilderness.' The Skeleton Coast is 16,000 square kilometres of national park that runs along the Atlantic coast of Namibia. The plants, insects, reptiles and small mammals that live there get their moisture from the dense ocean fogs, which form as the cold Benguela current blows inland. Larger animals such as the Cape fur seal live along the coast. Cape Fria is home to a colony of more than 100,000 individuals.

Canon EOS 5D with 24–105 mm lens at 47mm; 1/1250 sec at f5.6; ISO 500.

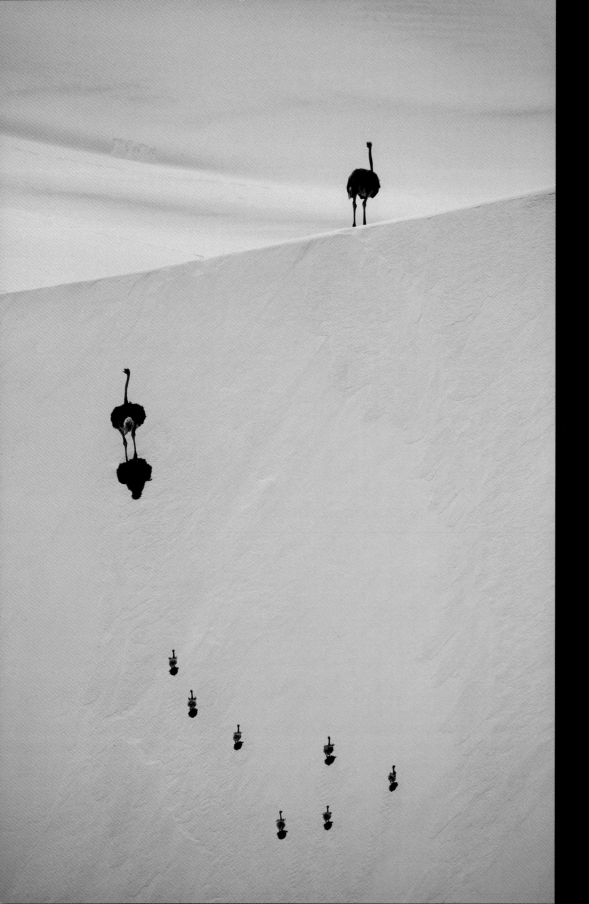

Sand sprinters
DAN MEAD

'The mother was in the lead, scouting the situation – a straggling chick, a strange vehicle, a vulnerable family. But its next move took me by surprise. It suddenly turned sharp right and headed straight up the nearest dune. It must have been 100 metres high and at an angle of 30 degrees. The sand slipped away under their feet. It was an amazing effort. The whole family disappeared over the crest of the Namibian dune.' Ostriches are the largest and fastest running birds on Earth. Their height, keen hearing and excellent eyesight make them able to spot danger quickly. If they do spot anything, they can run away at over 70 kilometres per hour.

Canon EOS 5D with Canon 100–400mm f4.5–5.6 IS USM lens at 400mm; 1/640 sec; f9; ISO 100.

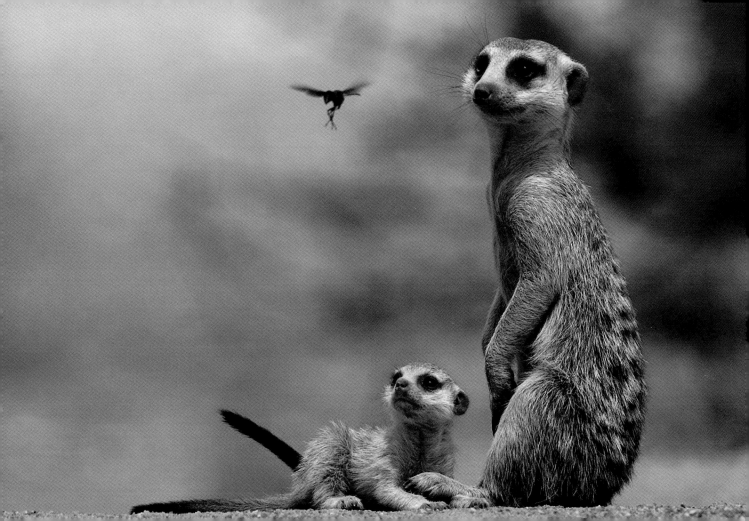

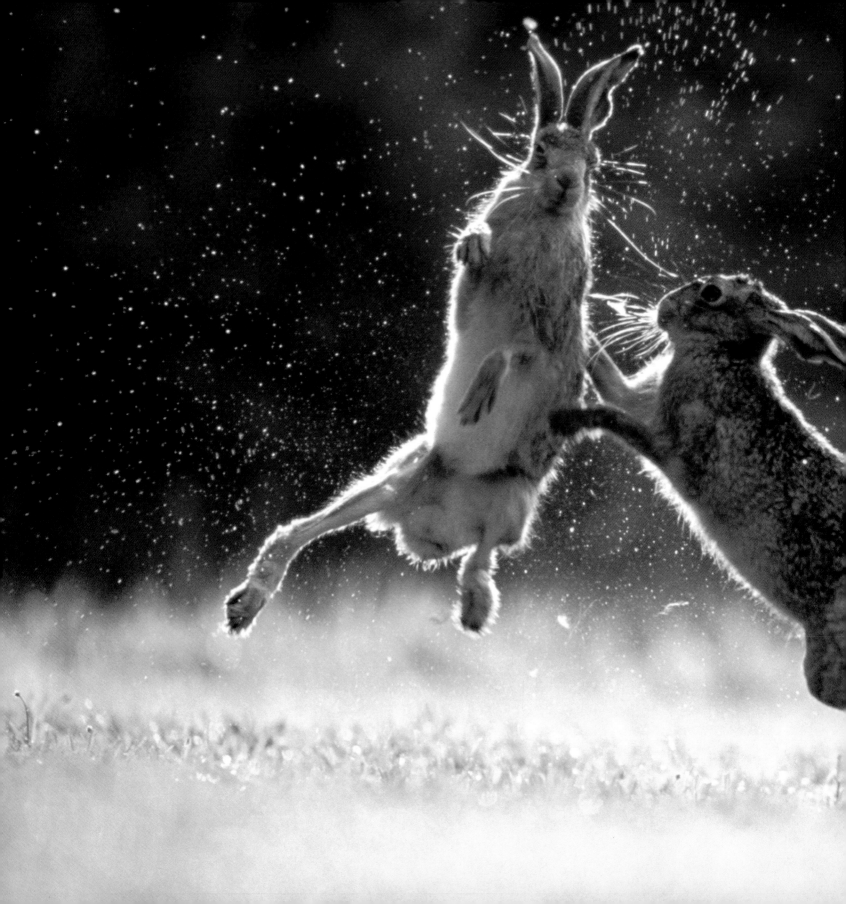

Boxing hares
MANFRED DANEGGER

'I have been photographing hares for 20 years, but sadly such opportunities are now rare as the hare population in Germany has diminished significantly. During the breeding season, in March and April, I spend long periods of time at a number of "favourite" sites along the edge of Lake Constance in southern Germany, hoping to capture the courtship behaviour of this shy creature.' The female hare in this photo is letting the male know she is not ready to mate yet by fighting off his advances. This is a natural process the female goes through in order to prepare herself for mating.

Nikon F4 with 400mm lens; 1/1000 sec at f2.8; Fujichrome Sensia 100.

Clash of the bulls

MARTYN COLBECK

Martyn was in Amboseli National Park, Kenya, one evening when he saw these two bulls about to fight. He set the camera at a low shutter speed to blur the scene because he wanted to create a sense of movement and power. The bull on the right has stopped while he tries to stop himself being twisted off his feet. If he had fallen, he might have been speared and killed by his opponent. In this instance he managed to escape and run away. Serious fights between bull elephants are rare, and competing bulls are usually of similar size and in a period of heightened sexual activity and aggression.

Canon EOS 1V with Canon EF 300mm f2.8 lens; 1/15 sec at f2.8; Ilford Delta 100; fluid-head tripod.

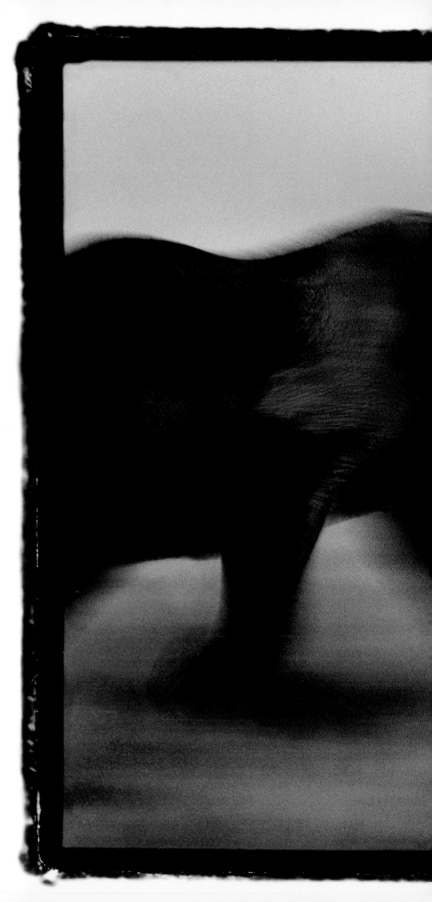

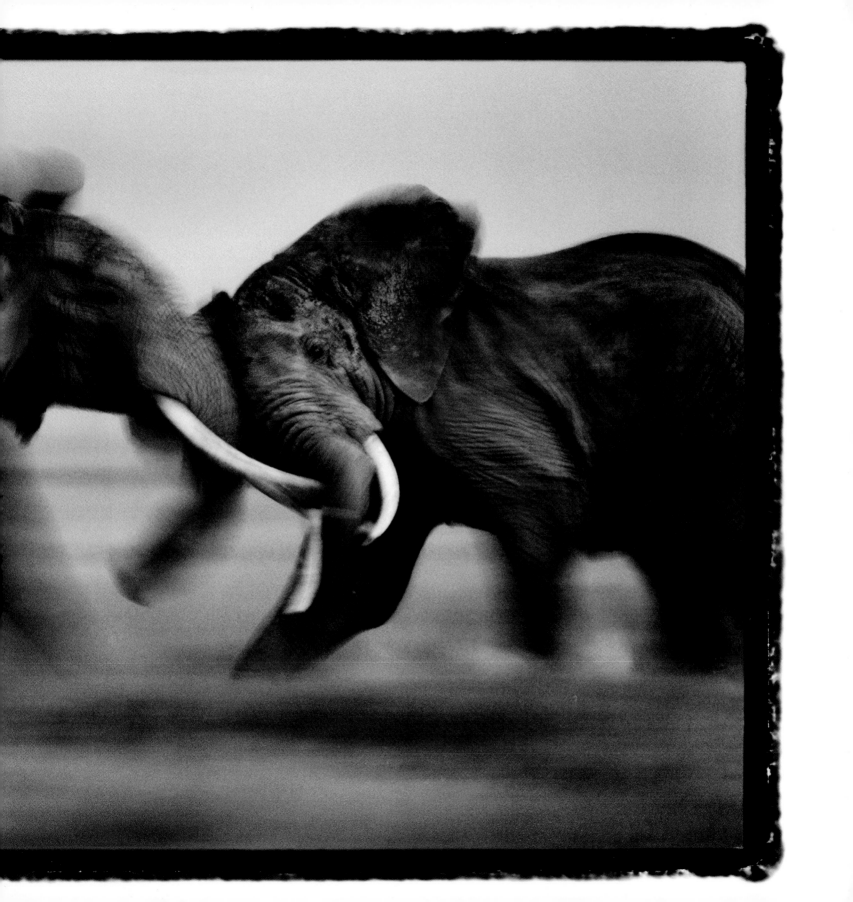

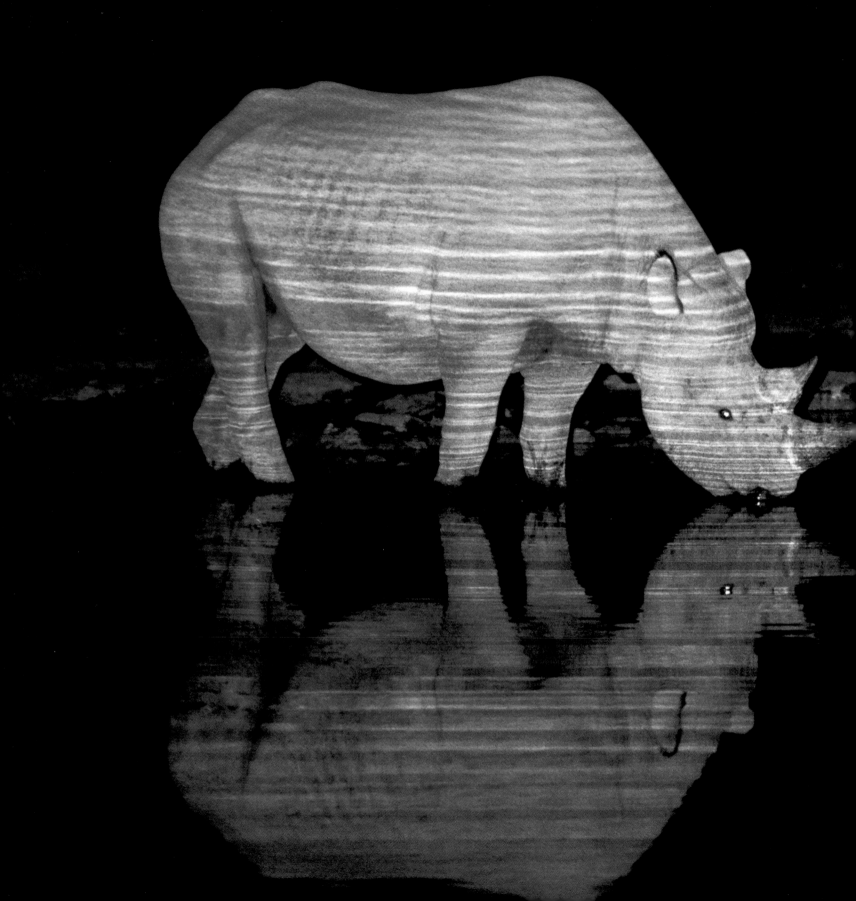

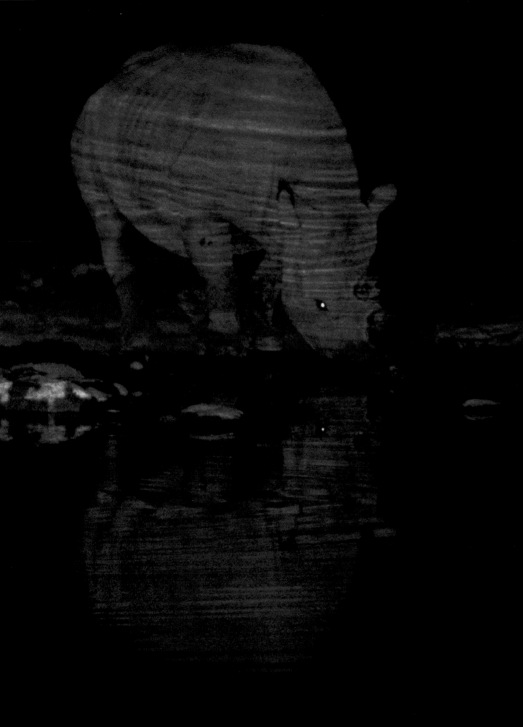

Rhinos drinking
WYNAND DU PLESSIS

'Black rhinos are usually solitary creatures, and in Etosha National Park, Namibia, mostly drink at night. However, at the waterhole interactions often occur between rhinos, as well as with other species such as lions and elephants, providing a fascinating insight into their social behaviour.' Black rhinos are critically endangered. Numbers were at their lowest in the mid-1990s, mainly as the result of poaching for prized rhino horn. However, a ban on international trade, as well as effective protection of the animals and their habitat, mean numbers are now on the rise.

Nikon N801S with 75–210mm lens; hand-held flash; Fujichrome 100.

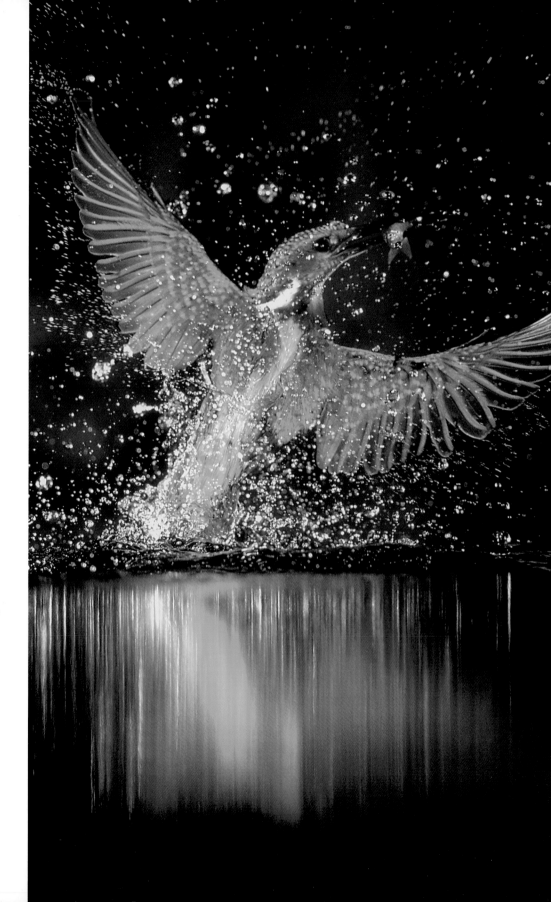

Kingfisher feeding

KÁRMÁN BALÁZS AND NOVÁK LÁSZLÓ

'We set a photo trap for the kingfishers in a frost-free area of this creek in Hungary by throwing in food, and continued to feed them until spring, when the ice melted.' Life is tough for kingfishers with many adult birds not surviving more than one breeding season. Harsh winters make life even tougher. When temperatures drop to below −15 degrees centigrade, some roosting birds may freeze. Icy waters also make fishing difficult, leading to starvation.

Canon EOS RT with EF-L 300mm lens; 1/125 sec at f6.7; Fujichrome Velvia rated at 40; four Canon EZ 540 flashes; self-made photo-electronic barrier.

Black-headed gulls on weir

RAOUL SLATER

'The famous stone Pulteney Bridge in Bath, UK, had caught the late autumn sunshine and reflected golden light onto the elegant weir below. These black-headed gulls braved cold feet and stood on top of the weir creating a wonderful pattern.' Gulls keep their feathers in top condition by wading out into water, fluffing their feathers and flicking up water so it runs onto their skin and onto their back feathers.

Canon EOS A2 with 75–300mm lens; 1/30 sec at f5.6; Fujichrome Velvia.

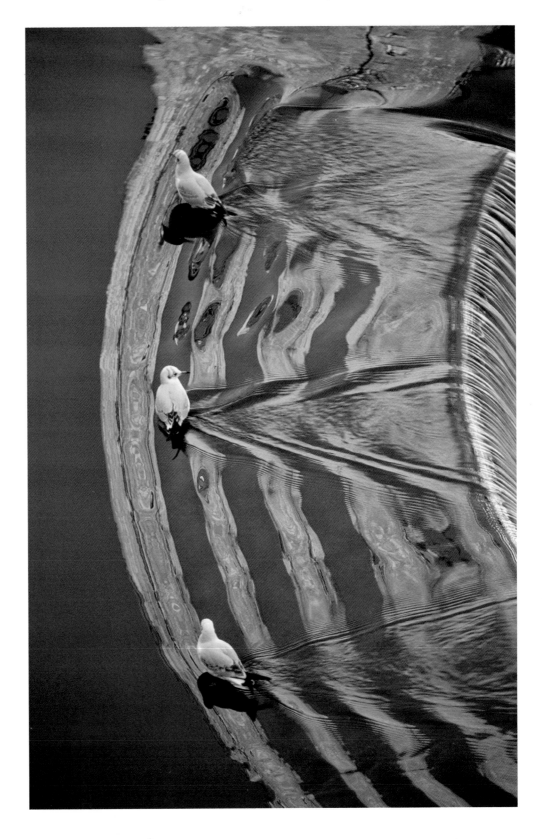

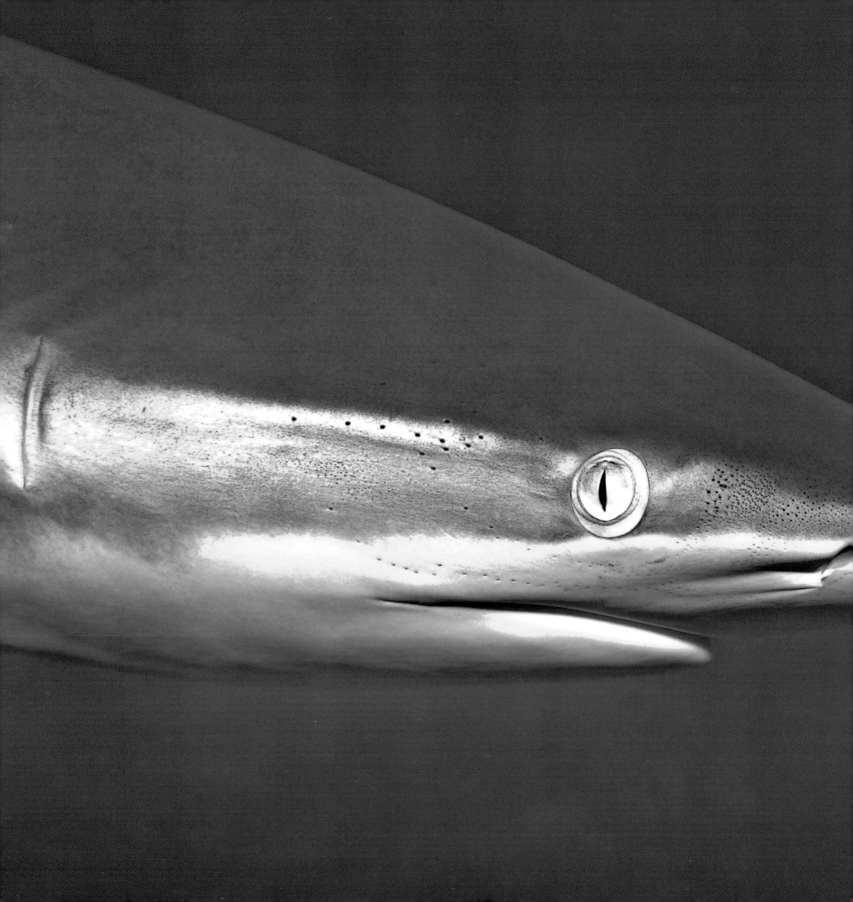

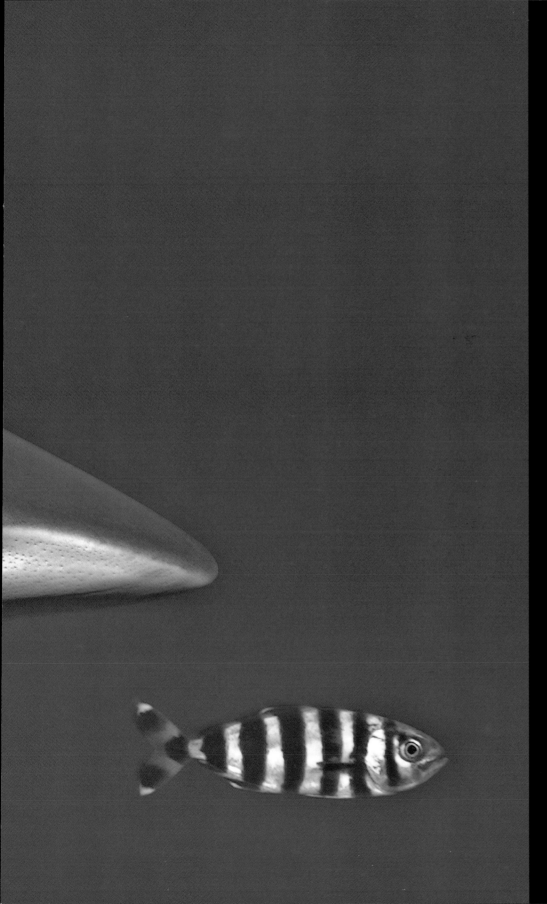

Big fish, little fish
LEN DEELEY

Len was diving in the Red Sea in search of sharks when this silky shark came by, looking at him. 'Just as it made a close pass I shot its profile. The pilot fish was in front, its usual position, as if attached by an invisible wire.' Pilot fish often swim in front of sharks. It could be to benefit from their protection, or perhaps to feed on scrap food. Small pilot fish may even swim into a shark's mouth to nibble food between its teeth. The shark rarely eats the fish.

Nikon D70s with 60mm f2.8 lens; 1/60 sec at f5.6; ISO 200; Sea & Sea housing; two Inon flashguns.

Crown jellyfish jewel

PETE ATKINSON

Pete was intending to photograph a reef
of hard corals encircling the South Pacific
island of Niue. Then he spotted this crown
jellyfish floating by. 'I drifted alongside
it in the current and was carried out into
the blue. To get a dramatic sunburst, I
underexposed the background and used
flash to add colour. I was so mesmerised by
the pulsating image in my viewfinder that
I lost all sense of how far I had gone. Once
the film was exhausted, I surfaced, scanned
the horizon for my dinghy and realised it
was going to be a long swim back.'

*Subeye Reflex with 13mm R-UW AF Fisheye
Nikkor lens; 1/125 sec at f11/16; Fujichrome
Velvia; Ikelite substrobe 200.*

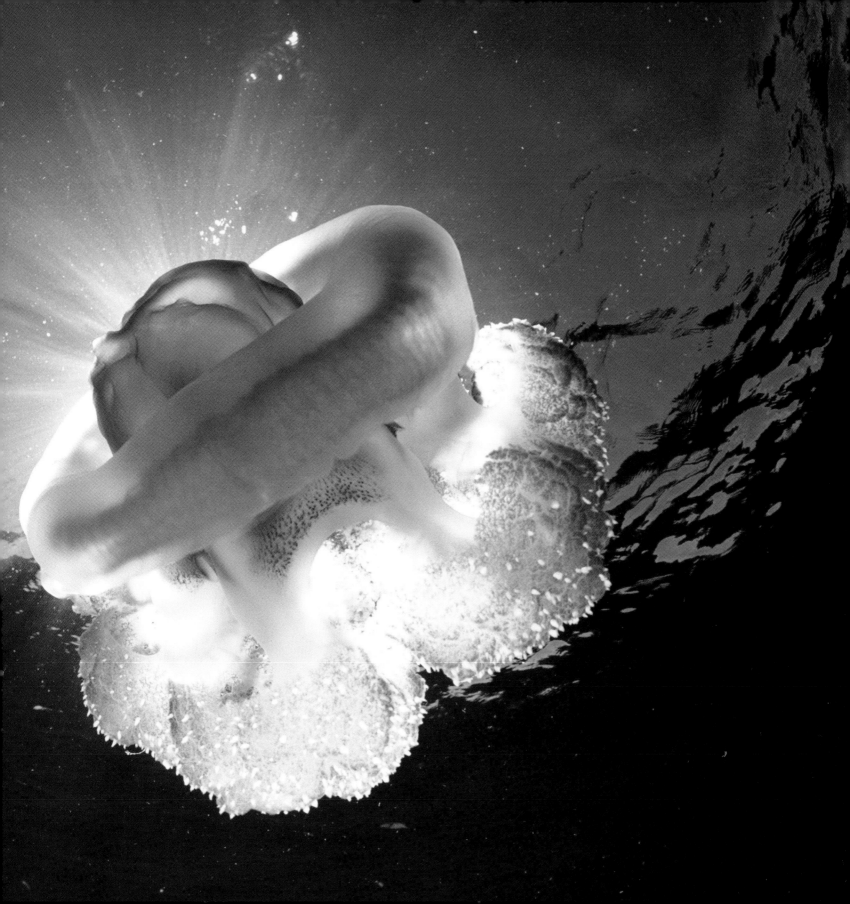

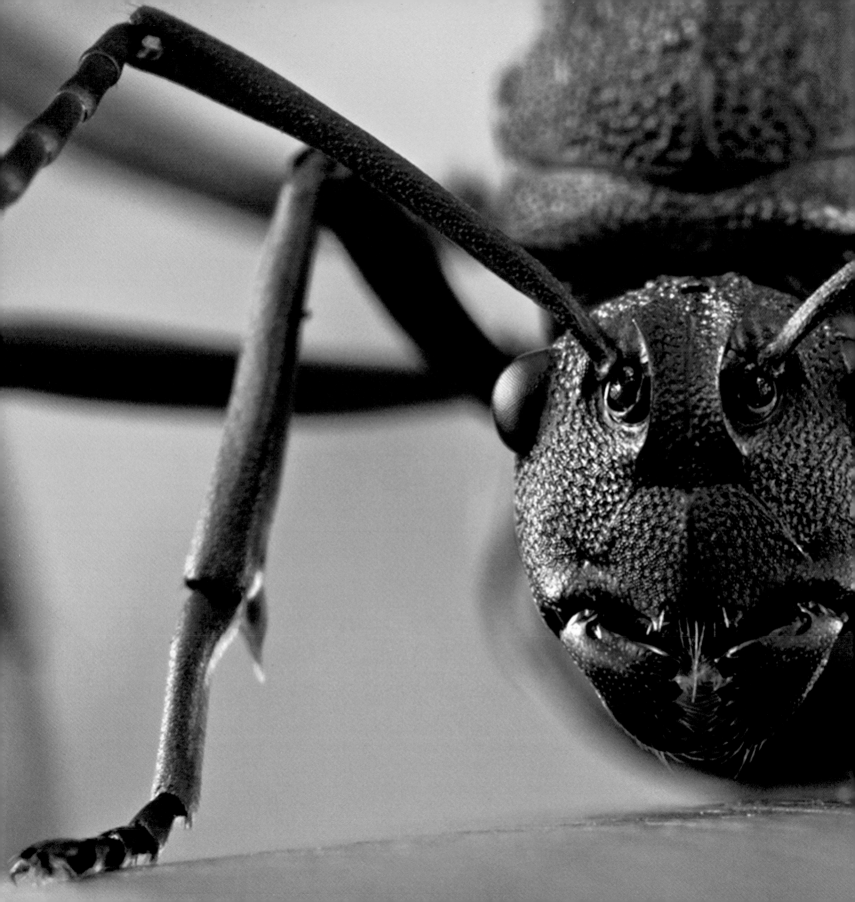

Angry queen
PIOTR NASKRECKI

'I put a portable diffusion box over the queen ant to smooth out the reflection from its shiny armour. The ant soon made its feelings clear by bending its abdomen forwards, ready to spray me with formic acid. I quickly released it, so it could go forth and multiply in its Cambodian home. Armoured ants, as their name suggests, are equipped with incredibly hard exoskeletons and sharp spines. Once a year, the nest produces many new queens and males. A new queen will mate with one or more males before flying off to begin a colony of her own. The queens are able to store the male ant's sperm internally and will use this to fertilise millions of eggs during their lifetime.

Canon EOS-1D Mark II + Canon MP-E 65mm macro lens; 1/160 sec at f16; 400 ISO; Canon MT-24EX and two Canon 580EX flashes + small diffusion box.

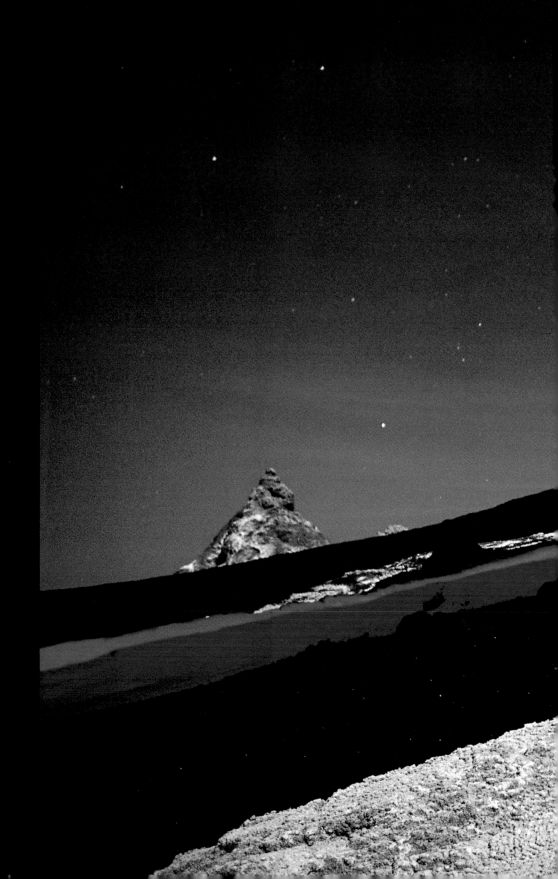

Lava by moonlight

OLIVIER GRUNEWALD

To take this picture, Olivier had to camp at the summit of Ol Doinyo Lengai volcano in Tanzania's Rift Valley and wait for a clear sky and a full moon before getting as close as he dared to the lava flow. Like a blood-red river in the moonlight, it is the fastest flowing lava in the world, containing very little silicon and is considered 'cold' at only about 510 degrees centigrade, compared with more than 1,100 degrees centigrade for most other lavas.

Nikon F100 with 28mm f1.4 lens; 30 sec at f2; Fujichrome Provia 100 rated at 200; tripod.

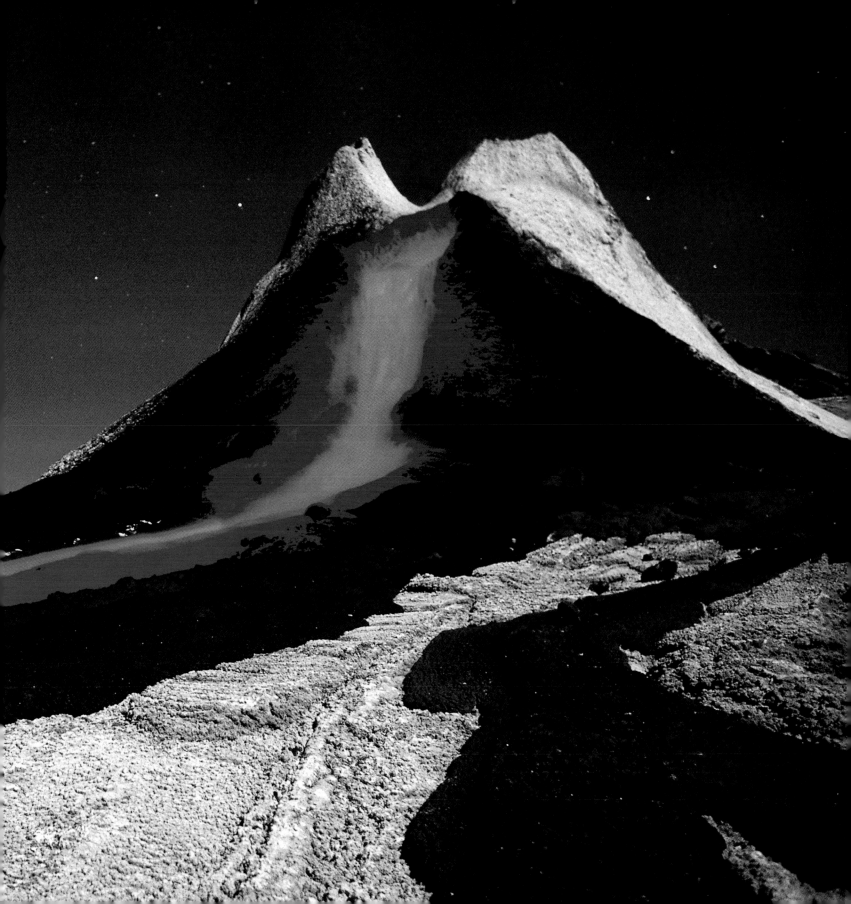

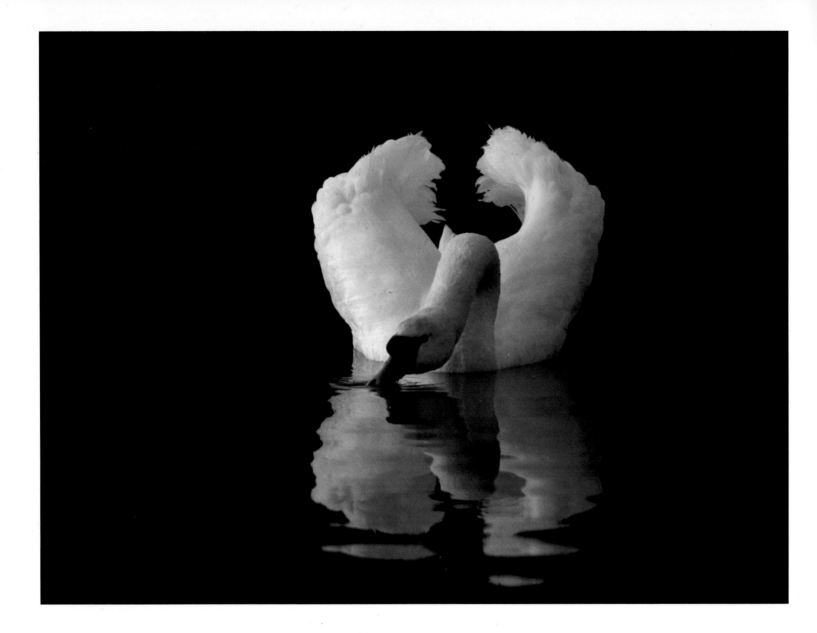

Mute swan

BECKY L CHADD

By the end of winter or early spring, mute swans have already marked out their territories for the breeding season. They are known to be territorial and can be very aggressive. 'I suppose this cob [a male mute swan] saw me as an intruder. He drew himself up into the classic threat posture, which had double the impact being reflected in the dark water.'

Canon EOS 50E with 80–200mm lens; 1/350 sec at f5.6; Fujichrome Sensia II 100 rated at 200; tripod.

Queen tree wasp building her nest

DAVID MAITLAND

'One spring, a tree wasp queen founded her nest in our hen-house in the UK. This photograph shows her brooding her tiny pearl-like eggs at the base of each cell.' Until her daughters are born, the wasp queen toils alone, constructing the elaborate nest from chewed wood. Nests expand as more daughters are born and can end up home to up to 5,000 wasps.

Olympus OM4Ti, with 80mm macro lens; 1/60 sec at f16; Kodachrome 64; Olympus T10 ring flash; extension tubes.

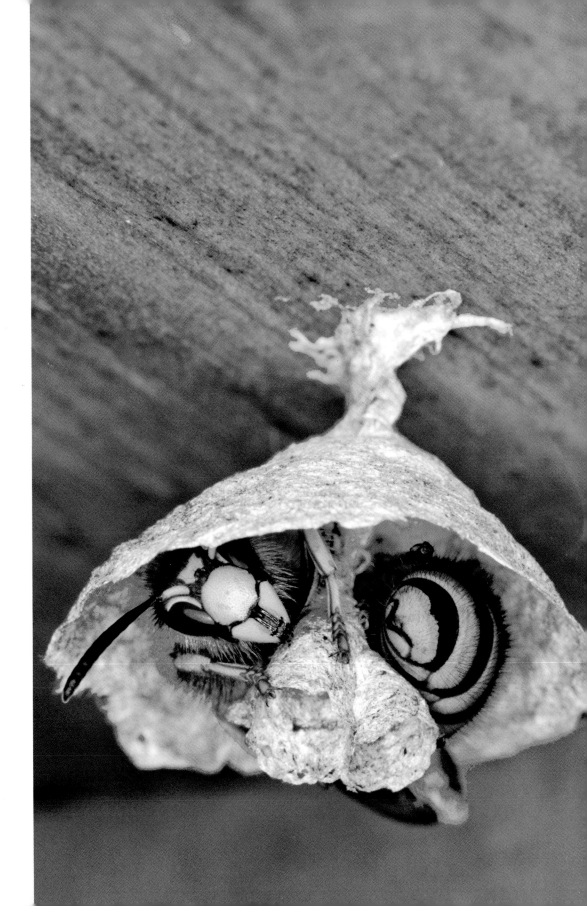

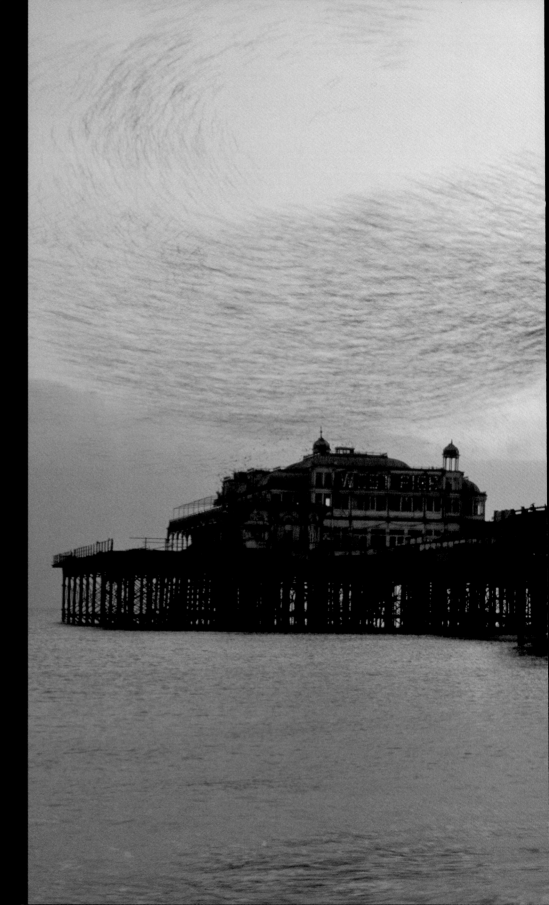

Starling flock above West Pier

JAMES WARWICK

James took this photo of Brighton's derelict West Pier in the UK a few years before it was partly destroyed by fire and a freak summer storm in 2004. 'Every evening the starlings would congregate. Small flocks would arrive first, from all directions, but before settling down for the night the whole gathering would perform the most wonderful acrobatic displays. They were like iron filings in a magnetised sky.' In autumn many starlings from the continent head to the UK for the milder winter, swelling the population and roosting throughout the country.

Nikon F90x with 28–80mm lens; Fujichrome Sensia 100; tripod.

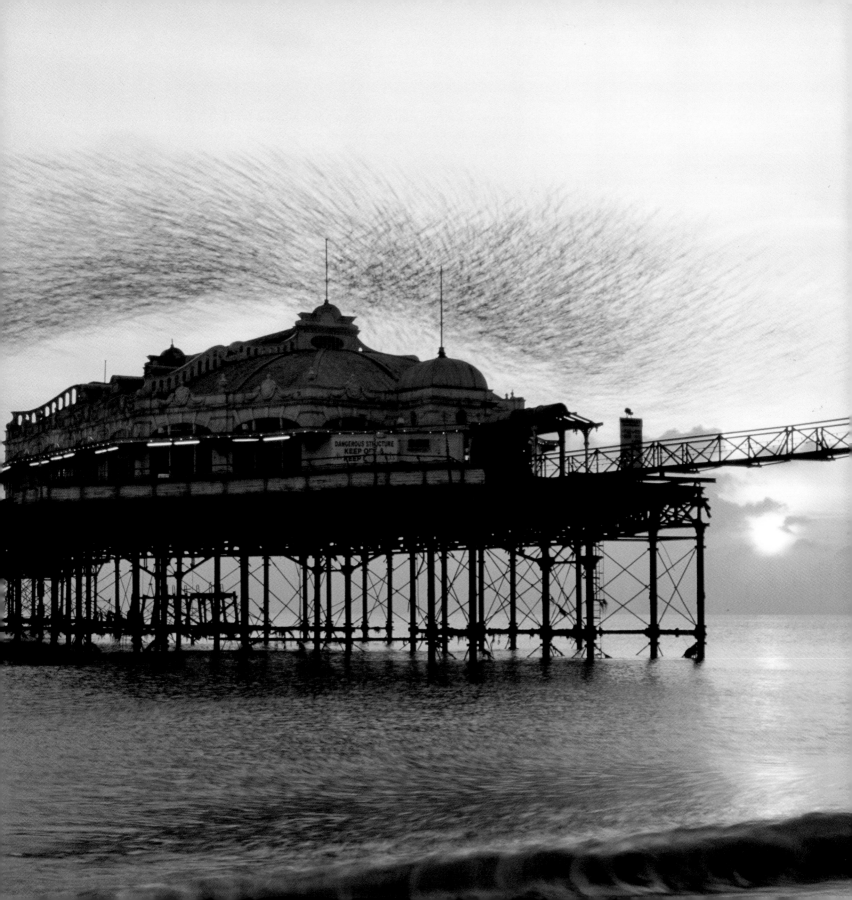

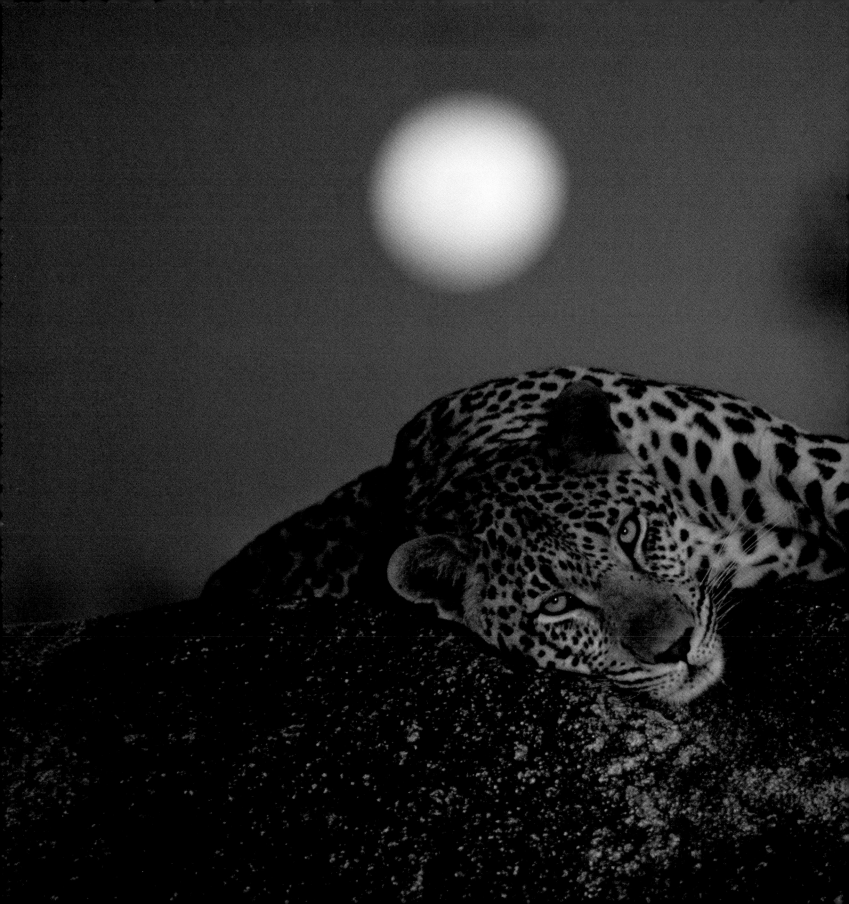

Leopard with rising moon

JAMIE THOM

'I first met this two-year-old leopard when he was only three months old and still with his mother in the Mala Mala Game Reserve, South Africa. It usually takes a while for leopards to become accustomed to vehicles, but he showed little fear from the outset. He was particularly curious and adventurous, practising his stalking on adult rhinos and giraffes and giving them the fright of their lives.' After 15 minutes of photography, the moon began to rise, providing a dramatic backdrop to the relaxed portrait.

Nikon F90x with 300mm lens; 1/30 sec at f4; Ektachrome E200; beanbag and spotlight.

Herring gull
OLIVER KOIS

'On holiday with my family in France, we stopped at Étretat on the Normandy coast. We climbed a hill to admire the fabulous view when, suddenly, this herring gull appeared right in front of me. We stared at each other for a few moments, and then I took this picture.' Herring gulls are a common coastal bird, and colonies nest on cliffs like these during the breeding season.

Canon EOS 300 with 20mm lens; 1/90 sec at f; Fujichrome Sensia 100; flash.

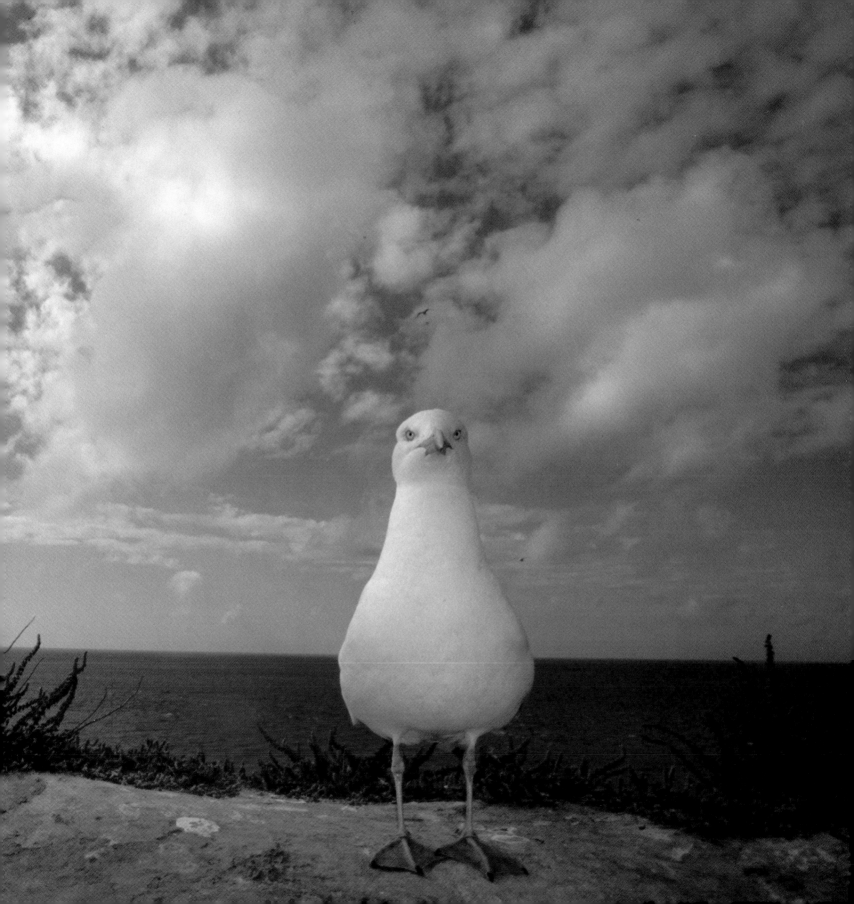

Index of photographers

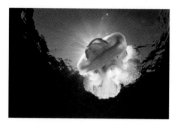

124-125, **Pete Atkinson**
2003, *The Underwater World*
Runner-up
yachtvigia@hotmail.com
www.peteatkinson.com
Agent
sales@gettyimages.co.uk
www.gettyimages.com

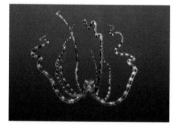

100-101, **Michael AW**
2006, *The Underwater World*
Winner
one@michaelaw.com
www.michaelaw.com

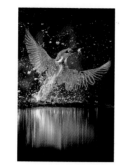

120, **Kármán Balázs and Novák**
László
2001, *Animal Behaviour Birds*
Highly Commended
nl@novaklaszlo.hu
www.novaklaszlo.hu
www.naturephoto.hu

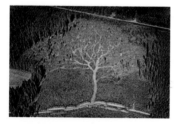

76-77, **Jocke Berglund**
2006, *The World in Our Hands*
Winner
flygbilder@telia.com
www.fotoflyget.se

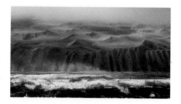

110-111, **Andy Biggs**
2008, *Wild Places*
Winner
andybiggs@gmail.com
www.andybiggs.com

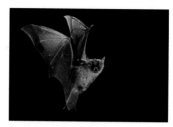

41, **Carsten Braun**
2008, *Animal Portraits*
Specially Commended
carsten.braun@web.de
www.braun-naturfoto.de

70-71, **Olaf Broders**
1999, *In Praise of Plants*
Winner
obroders@web.de
www.broders-photo.de

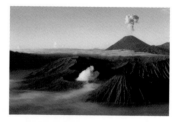

8-9, **Dan Brooks**
1998, *Wild Places*
Highly Commended
dan@eastimages.com
www.eastimages.com

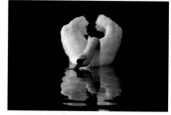

130, **Becky L Chadd**
1999, *Young Wildlife*
Photographer 11-14 years
Winner
becky_chadd@hotmail.com

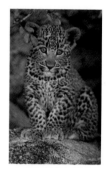

80, **Peter Chadwick**
1998, *Animal Portraits*
Highly Commended
wildlifex@iafrica.com

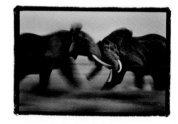

116-117, **Martyn Colbeck**
2005, *Nature in Black and White*
Runner-up
martyncolbeck@compuserve.com
Agent
enquiries@osf.uk.com
www.osf.co.uk

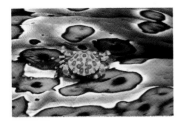

15, **Brandon D Cole**
1995, *The Eric Hosking Award Winner*
brandoncole@msn.com
www.brandoncole.com

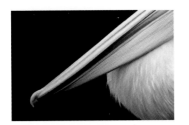

47, **Wesley Cooper**
2007, *Nature in Black and White Highly Commended*
wes.cooper@gmail.com
www.wescooperphotography.com.au

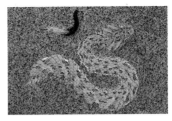

10-11, **Thomas Dressler**
2002, *Animal Portraits Highly Commended*
info@thomasdressler.net
www.thomasdressler.net
Agent
www.ardea.com

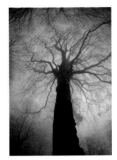

105, **Luca Fantoni and Danilo Porta**
2005, *Nature in Black and White Highly Commended*
fantoniluca4@alice.it
danilo.porta@alice.it

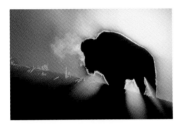

64-65, **Mervin D Coleman**
2001, *Animal Portraits Winner*
colemanstudio@cablemt.net
www.colemangallery.biz

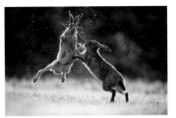

114-115, **Manfred Danegger**
1998, *Overall Winner*
tierfotodanegger@t-online.de

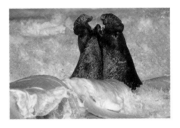

118-119, **Wynand du Plessis**
1998, *The Gerald Durrell Award Highly Commended*
clawyn@iway.na
wdupnam@yahoo.com
www.claudiawynandduplessis.com

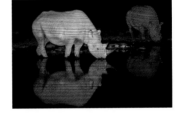

24-25, **Tim Fitzharris**
2001, *Animal Behaviour Mammals Winner*
fitzharris@comcast.net
timfitzharris@comcast.net
www.timfitzharris.com

113, **Shem Compion**
2007, *Behaviour Mammals Specially Commended*
shem@shemimages.com
www.shemimages.com

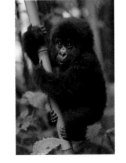

122-123, **Len Deeley**
2007, *The Underwater World Highly Commended*
len.deeley@btinternet.com
www.image-photography.co.uk

4 & 73, **Suzi Eszterhas**
2006, *Gerald Durrell Award for Endangered Wildlife Specially Commended*
suzi@suzieszterhas.com
www.suzieszterhas.com
Agents
www.mindenpictures.com
www.naturepl.com

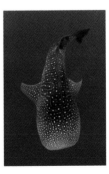

96, **Jürgen Freund**
1997, *The Underwater World Highly Commended*
freundfactory@gmail.com
freundimages@gmail.com
www.jurgenfreund.com
Agents
www.naturepl.com

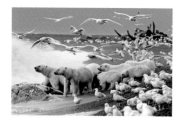

32-33, **Howie Garber**
2003, Animal Behaviour Mammals
Specially Commended
howie@wanderlustimages.com
www.wanderlustimages.com

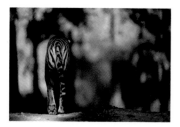

12-13 & back cover, **Nick Garbutt**
2000, The Gerald Durrell Award
for Endangered Wildlife
Winner
nickgarbutt@nickgarbutt.com
www.nickgarbutt.com

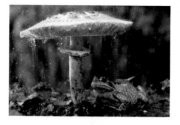

74-75, **Edwin Giesbers**
1999, Animal Behaviour All Other
Animals
Highly Commended
info@edwingiesbers.com

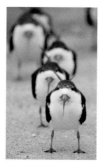

30, **Evan Graff**
2007, Young Wildlife
Photographers 15-17 years
Winner
egraff89@yahoo.com
www.philzworld.com/evanzworld/

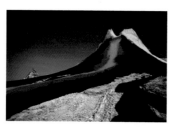

128-129, **Olivier Grunewald**
2005, Wild Places
Runner-up
bernadette.gilbertas@wanadoo.fr

52-53, **Tore Hagman**
2004, Animal Portraits
Specially Commended
info@torehagman.se
images@tiscali.se

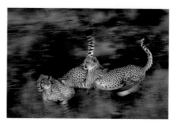

42-43, **Gerald Hinde**
2004, Animal Behaviour Mammals
Highly Commended
hinde@netactive.co.za
www.geraldhinde.com

90-91, **Jan Töve Johansson**
2000, In Praise of Plants
Highly Commended
jan.tove@telia.com

57, **Helen A Jones**
2000, Composition and Form
Runner-up
helenjones@nl.rogers.com

46, **Mark Jones**
2004, Behaviour All Other Animals
Highly Commended
photos@rovingtortoise.co.nz

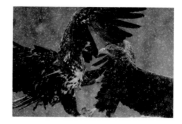

108-109, **Antoni Kasprzak**
2008, Behaviour Birds
Winner
www.antonikasprzak.net

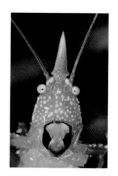

14, **Brian Kenney**
1994, Animal Portraits
Runner-up
briankenney@netzero.net
www.agpix.com/briankenney

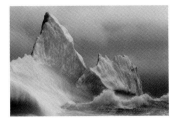

50-51, **Robert Knight**
2007, Wild Places
Winner
info@robertknightgallery.com
www.robertknightgallery.com

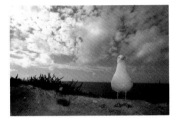

136-137, **Oliver Kois**
2002, Young Wildlife
Photographers 11-14 years
Runner-up

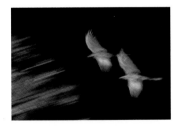

94-95, **Claudio Contreras Koob**
2002, Composition and Form
Runner-up
cckoob@yahoo.com
www.claudiocontreras.com

122, **Novák László** see
Kármán Balázs

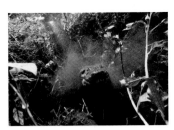

86-87, **Michel Loup**
2006, Animals in Their
Environment
loupmichel@wanadoo.fr
www.michelloup.com

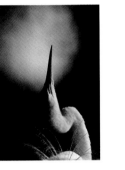

104, **David Macri**
2004, Animal Portraits
Winner
david@davidmacri.com
www.davidmacri.com

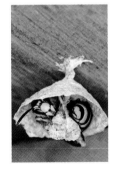

131, **David Maitland**
2003, Behaviour All Other Animals
Highly Commended
dpmaitland@googlemail.com
david@davidmaitland.com
www.davidmaitland.com

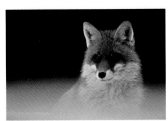

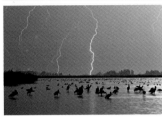

26-27 & 66-67, **Bence Máté**
2003, Animal Portraits
Highly Commended
2007, Eric Hosking Award
bence@matebence.hu
www.matebence.hu
www.hidephotography.com
Agent
ferenc@hidephotography.com

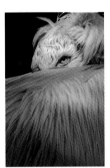

38-39, **Armin Maywald**
2000, From Dusk to Dawn
Runner-up
arminmaywald@aol.com

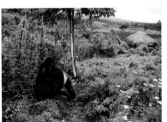

54-55, **Joe McDonald**
2006, The World in Our Hands
Runner-up

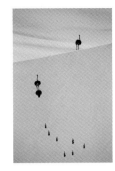

112, **Dan Mead**
2008, Animals in Their
Environment
Highly Commended
dansal@mac.com
www.meadeaglephotos.com

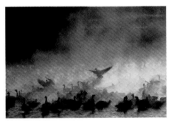

7 & 89, **Helmut Moik**
2003, Animal Portraits
Winner
wildlifefoto.moik@aon.at
www.natureasart.at

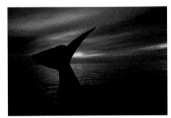

2 & 78-79, **Arthur Morris/Birds**
as Art
2001, From Dusk to Dawn
Highly Commended
birdsasart@att.net
www.birdsasart.com
www.birdphotographers.net

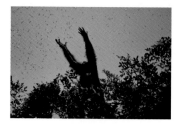

92-93, **Kristin J Mosher**
2005, Animal Behaviour Mammals Winner
kjmosher@mac.com
Agents
danita@danitadelimont.com
www.danitadelimont.com
enquiries@osf.uk.com
www.osf.co.uk

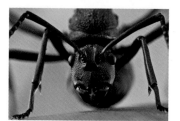

126-127, **Piotr Naskrecki**
2008, Animal Portraits Highly Commended
p.naskrecki@conservation.org
www.insectphotography.com
Agent
www.mindenpictures.com

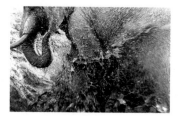

68-69, **Ben Osborne**
2007, Overall Winner
ben@benosbornephotography.co.uk
www.benosbornephotography.co.uk
Agents
www.gettyimages.com
www.naturepl.com

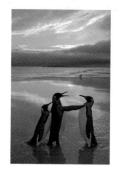

22, **Andy Rouse**
2006, Animal Behaviour Birds
andyrouse@mac.com
www.andyrouse.co.uk

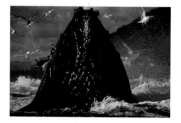

102-103, **Duncan Murrell**
2002, Animal Behaviour Mammals Winner
dunks45@hotmail.com
www.duncanmurrell.com

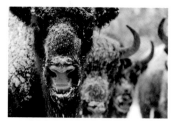

28-29, **Klaus Nigge**
2004, Gerald Durrell Award for Endangered Wildlife Winner
klaus.nigge@t-online.de
www.nigge.com
Agents
www.nationalgeographicstock.com

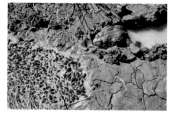

36-37, **Mark Payne-Gill**
2001, Animal Behaviour Other Animals Runner-up
mark@payne-gill.freeserve.co.uk

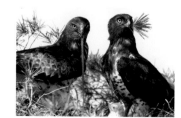

58-59, **José B Ruiz**
2005, Animal Behaviour Birds Highly Commended
josebruiz@josebruiz.com
www.josebruiz.com
Agent
info@naturepl.com
www.naturepl.com

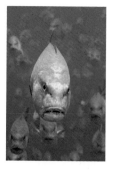

88, **Alexander Mustard**
2005, Animal Portraits Winner
alex@amustard.com
www.amustard.com

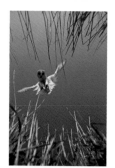

23, **Nick Oliver**
2003, Animal Behaviour Birds Winner
olivernj@btinternet.com

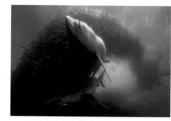

48-49, **Doug Perrine**
2004, Overall Winner Underwater world Winner
douglasperrine@yahoo.com
perrine@hawaii.rr.com
Agent
info@seapics.com
www.seapics.com

105, **Danilo Porta** see
 Luca Fantoni

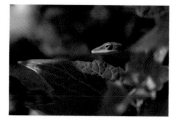

60-61, **Gabby Salazar**
2004, Young Wildlife Photographers 15-17 years Winner
gabby.r.salazar@gmail.com

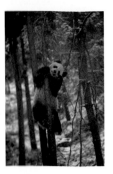

56, Tom Schandy
*2000, The Gerald Durrell Award
for Endangered Wildlife
Runner-up*
tschandy@online.no
www.tomschandy.no

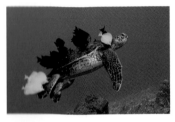

82-83, Andre Seale
*2006, Behaviour All Other Animals
Winner*
aseale@artesub.com
www.artesub.com

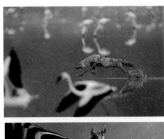

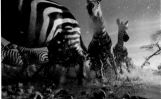

20-21 & 84-85, Anup Shah
*2004, Animal Behaviour Mammals
Winner
2007, Behaviour Mammals
Specially Commended*
info@shahimages.com
Agent
www.shahimages.com

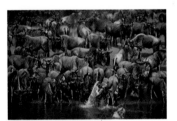

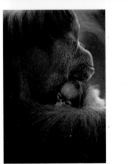

18-19 & 72, Manoj Shah
*1999, Animal Behaviour All Other
Animals
Highly Commended
Wildlife Photographer of the Year
2000*
info@shahimages.com
Agent
www.shahimages.com

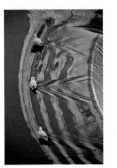

121, Raoul Slater
*1998, Urban and Garden Wildlife
Winner*
wilddog@spiderweb.com.au

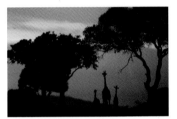

16-17, Gabriela Staebler
*2000, From Dusk to Dawn
Highly Commended*
gabrielastaebler@online.de
info@gabrielastaebler.de
www.gabrielastaebler.de

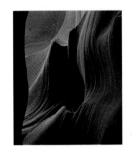

40, Mark Sunderland
*2000, Composition and Form
Highly Commended*
marks@marksunderland.com
www.marksunderland.com

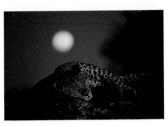

134-135, Jamie Thom
*Wildlife Photographer of the Year
1999*
jamiet@netactive.co.za
www.jamiethom.com

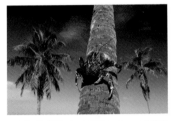

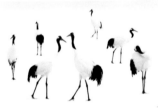

34-35 & 62, Jan Vermeer
*2006, Animals in Their
Environment
Winner
2006, Creative Visions of Nature
Runner-up*
janvermeer.foto@planet.nl
www.janvermeer.nl
Agent
www.fotonatura.com

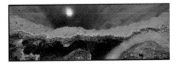

98-99, Benjamin D Walls
2006, Creative Visions of Nature
info@wallsphoto.com
www.wallsphoto.com

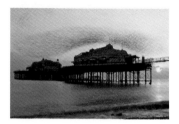

132-133, **James Warwick**
*1998, Urban and Garden Wildlife
Runner-up*
james@jameswarwick.co.uk
www.jameswarwick.co.uk
Agent
www.gettyimages.com

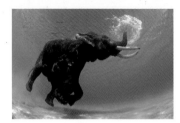

97 & front cover, **Jeff Yonover**
*2007, Gerald Durrell Award for
 Endangered Wildlife
Highly Commended*
jeff@jeffyonover.com
www.jeffyonover.com

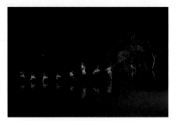

106-107, **Christian Ziegler**
*2007, Behaviour Mammals
Runner-up*
zieglerphoto@yahoo.com
www.naturphoto.de
Agents
www.danitadelimont.com
www.mindenpictures.com

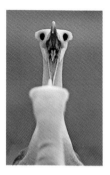

63, **Winfried Wisniewski**
*2003, Animal Behaviour Birds
Highly Commended*
w.wisniewski@t-online.de
www.winfried-wisniewski.de

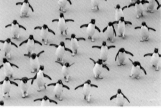

31 & 81, **Solvin Zankl**
*2003, The World in Our Hands
Highly Commended
2006, Animal Behaviour Birds
Specially Commended*
info@solvinzankl.com
www.solvinzankl.com
Agent
www.naturepl.com

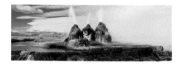

44-45, **Jeremy Woodhouse**
*2000, Wild Places
Winner*
jeremy@pixelchrome.com
www.pixelchrome.com

First published by the Natural History Museum, Cromwell Road, London SW7 5BD
© Natural History Museum, London, 2010

ISBN 978 0 565 09250 4

A catalogue of this book is available from the British Library.

Proofread by Lesley J Simon
Designed by Studio Gossett
Reproduction by Saxon Digital Services
Printing by C&C Offset Printing Co. Ltd

Find out more about Publishing at the Natural History Museum www.nhm.ac.uk/publishing